NATIONAL GEOGRAPHIC

PHOTOGRAPHY

FIELD GUIDE

ACTION & ADVENTURE

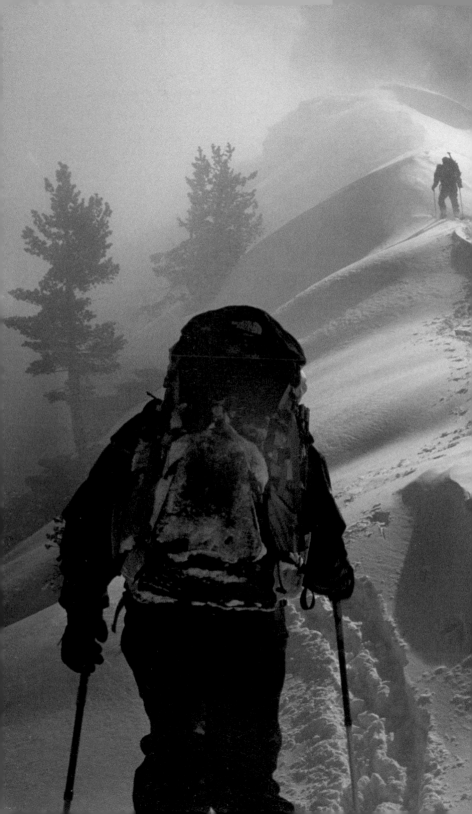

NATIONAL GEOGRAPHIC
PHOTOGRAPHY
FIELD GUIDE
ACTION & ADVENTURE

Text and photographs by BILL HATCHER

NATIONAL GEOGRAPHIC

WASHINGTON, D.C.

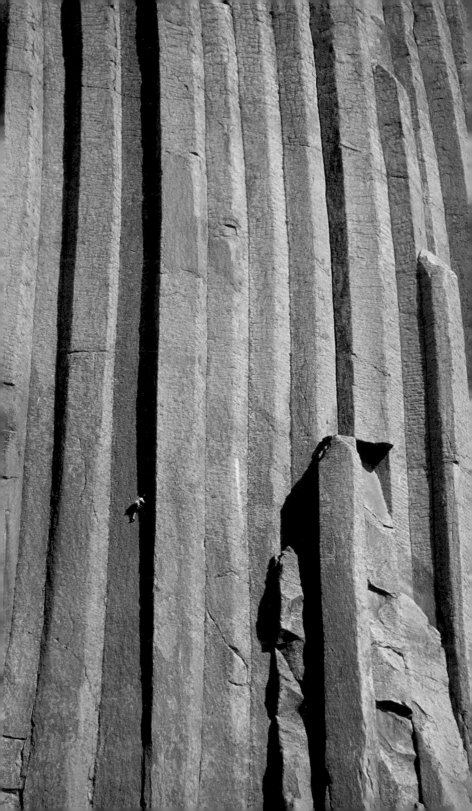

CONTENTS

PAGES 2-3: This photograph of skiers hiking a mountain ridge in blowing snow and clouds tells a story about the challenges of the mountains and of dealing with stormy weather.

OPPOSITE PAGE: To keep the strong vertical lines of the Devils Tower straight, I moved away from the base of the tower and shot it at a more level view with a 200mm lens. The tiny climber lends scale to the immense stone columns.

Ad-ven-ture *n* 1: the encountering of danger 2: a daring, hazardous undertaking 3: an unusual, stirring experience.

What comes to mind when you hear the word adventure? Unknown places, excitement, danger, fear, personal challenge? The best adventure photos elicit the same reactions. Unlike other forms of photography, adventure photography is an almost purely participatory activity, which explains some of the emotional response to the adventure image. Great adventure photography touches a nerve in the viewer, who responds with a feeling of being there in the scene. All of us have returned home from a great adventure only to be disappointed with our photos because they are missing the emotional impact and beauty we experienced on that once-in-a-lifetime trip. What happened? We witnessed greatness, yet our photos are boring.

The reality is that the camera simply is not hardwired into all of our senses and emotions when we click the shutter. Trying to capture the human drama of climbing a cold mountain, rafting down a swift-moving river, or hiking in a blistering hot desert is possible when you learn to translate what you see and feel through the medium of the camera. You will select elements in the scene you photograph much as a writer selects words to describe a place.

In the following chapters we'll explore the

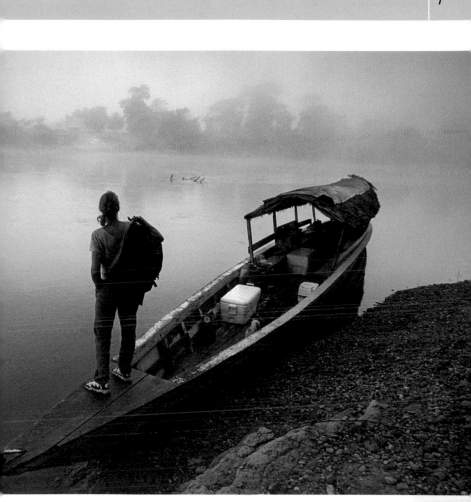

photography of adventure sports and adventure expeditions. Action and adventure photography can cross over to include activities such as rock climbing, river rafting, hiking, skiing, or desert or mountain trekking. We'll explore the unique challenges of shooting in remote places, selecting and using cameras in the field, and techniques for getting great photographs. This book will help you mix your photography with your favorite outdoor activities. Bring the book along and let's go outside. It's time to have some fun.

Capturing a river shrouded in fog was no accident, but a result of knowing ahead of time that early cool mornings are the best time to find fog and mist conditions on rivers and lakes.

IN SELECTING CAMERA GEAR for the backcountry you'll need to think carefully about what you are likely to need and use most on the trip. Since every trip is unique, you'll need to custom plan the photo gear you bring. Professional photographers do not have a single tried-and-true kit that they use on every shoot, and neither should you. Two important things to consider before you pack are how much you can carry, given the logistics of the trip, and what you will be shooting.

Camera gear, being heavy and bulky, conflicts with the main tenet of adventure photography, which is traveling light. To get around this there are strategies to packing photo gear for trips. In deciding how much gear you can afford to bring, look at what type of trip it is. There are two basic types of adventure trips. One is the self-supported backpacking-style trip, in which you must carry all of your gear during your entire time in the field. The second is the base camp style trip, in which you transfer everything but the kitchen sink to a central place from where you can then make short trips—a rafting trip, or a pack trip by horse in the mountains, for example. Packing for each of these modes of travel varies considerably.

Two extreme examples of packing occurred for me within a period of a few months. On the first shoot, I was in the Brooks Range in

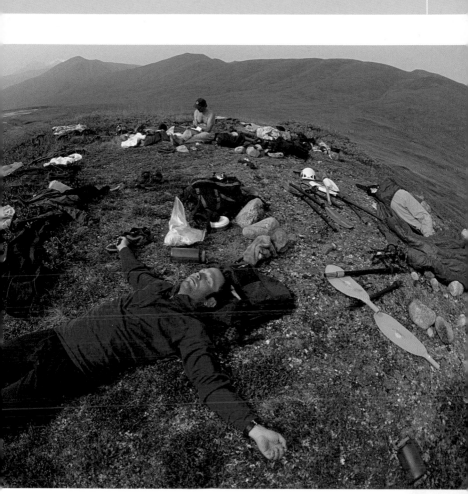

Alaska, where I carried all my stuff in a pack for a couple of weeks. The second trip involved travel to a remote island off the coast of Panama, where I established and worked from a base camp. In Panama four of us traveled with ten cases of photo and camping gear. The gear included five camera bodies; two video cameras; sound equipment; many lenses; flashes; underwater camera housings; wireless remotes; light reflectors; soft boxes; solar panels; and a deep-cycle marine battery to recharge digital camera and video batteries.

The explosion of expedition gear seemed best photographed with an equally explosive lens, in this case a 16mm fish-eye lens that captures 180 degrees of view. The exhausted figure in the foreground and the landscape behind add details to the story.

"Survival" gear included five tents, cooking gear, tables, chairs, lights, food for seven people for two weeks, climbing equipment and rope, a portable tree platform, and even a small inflatable boat. Transporting this mountain of gear involved hiring a truck and driver to carry things from the airport in Panama City to the beach launch where we chartered a 27-foot boat to move the gear 60 miles out to our island base camp.

Contrast this with my trip to the Brooks Range. During the two-week, self-supported expedition in Alaska, my camera gear, carried in a waterproof camera bag, consisted of one camera body, two lenses, three filters, and 30 rolls of film. My 45-pound pack also contained my food and sleeping gear, a portable boat and paddle to descend and cross rivers, and a backup camera, which I never used.

My total camera kit in Alaska weighed under seven pounds, but as in Panama, my selection of photo equipment was well planned and worked well as an effective photo system. These are two extreme examples of packing, but I chose them to illustrate the importance of the thought and planning that should go into selecting each item.

To begin selecting the type of camera equipment you will bring on a trip, try to imagine the photo situation you will place yourself in. Before an expedition I study and research my destination and try to visualize the photo possibilities. For example, if you are going on a safari in Africa your primary lens may be a big telephoto. If you are going someplace where you'll be more confined, such as a sailboat cruise, a trek on horseback, or climbing a big wall, a wide-angle zoom lens will work best.

Tip

Though useful for holding big heavy lenses, and for long exposures, tripods usually slow the action photographer down. Think very carefully about your use of the tripod before you bring one. A monopod is a very lightweight alternative to a tripod for following action and shooting with a big lens.

Transporting Your Gear

Before talking about the perfect photo kit for your trip it's important to emphasize protecting your equipment in the field. All adventure trips push the comfort envelope of your camera gear. The ultimate protection for camera gear is the waterproof, shock-absorbing foam-lined plastic hard-shell case. These come in all sizes, my favorite being the size of a briefcase and about five inches deep. The case protects cameras from water, dust, and most important, the bump and grind of daily travel. The constant vibration from driving on dirt roads and flying in puddle-jumping small planes has vibrated the screws right out of my lenses and

The compact digital camera system is almost pocketable, weighs about three to eight ounces, and is perfect when the most lightweight system is needed. A typical compact system will fit in a small padded camera pouch with a shoulder strap. Shown: Compact point-and-shoot pocket digital with zoom lens; two extra memory cards in protective case; one extra battery; mini tabletop tripod.

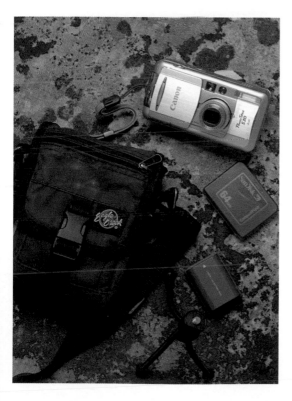

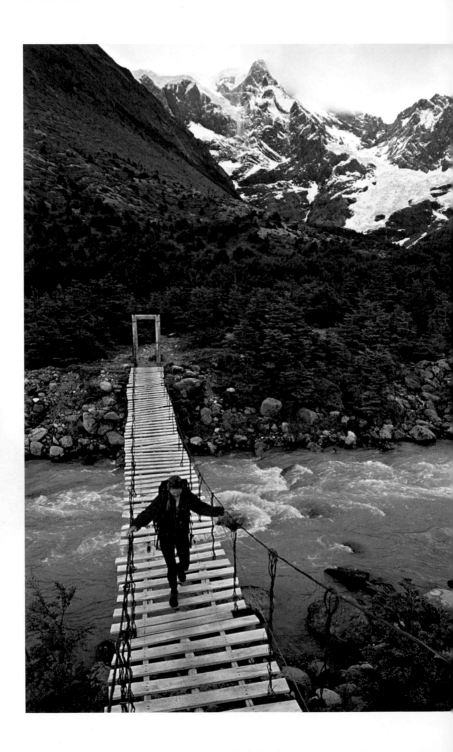

cameras. Once, after days of bone-jarring driving on dirt roads in southern Africa, the front glass element of my 20mm lens backed out of my lens. Because the hard case is such great insurance from damage during transport to the shoot and from the shoot, it's a good idea to make room for it if you can. The hard case can easily be packed inside soft luggage, such as expedition duffle bags, without worry. Once I reach my destination I usually transfer my cameras into a more convenient shoulder camera bag.

There are many options for carrying your cameras. Most adventure photographers use the hip-belt style camera bag with a shoulder strap. If the shoulder strap that comes with the bag is a cheap nylon strap, toss it and replace it with a comfortable shoulder strap with a non-slip rubber surface, since you'll often be carrying the camera bag slung over your shoulder while wearing a slick nylon parka.

The hip bag is similar to most soft camera bags, but can be used in a number of configurations. You can use it with just a shoulder strap, or you can also clip the integral hip belt around your waist. The combination of the shoulder strap and hip belt helps to distribute the weight of the camera bag and stabilize and secure the bag should you be running to grab a shot, riding a horse, or rappelling off a cliff. The hip bag can be worn on your side or back, then swiveled to your front for quick access.

Most hip shoulder bags hold one camera with a lens, one lens, a flash, spare batteries, five to eight rolls of film or digital cards, some filters, and a couple of energy bars. Because your camera will be around your neck, ready to use, when you're on the trail the hip bag is fairly light on the shoulder. The largest hip

The most frequently used lens for adventure photography is the wide-angle zoom lens, because it allows you to shoot when space to move around is limited. Here, I used a 17-35 zoom at its wide setting. By climbing above the bridge, I got a unique perspective that captured both the bridge and the mountains behind it.

bags can accommodate big telephoto lenses. Gear not in the hip bag, such as extra batteries, a tripod, a backup body and lens, extra film or digital medium, and big lenses, can be carried in a backpack or left in a hard case on the floor of the 4x4 or, if you are shooting near camp, in your tent. Loose camera items not in the hip pack or in a hard case can be organized in Ziploc bags and in lightly padded camera accessory bags.

Other options for travel protection are camera backpacks. These work well for travel and fit in a plane's overhead compartments. Although popular with landscape and wildlife photographers who carry large-format cameras and big telephotos, they are not as suitable for adventure because they are not as quickly accessible as a smaller hip bag. The large one-camera-bag-fits-all system is simply too big and cumbersome in real field situations. If you want to go really simple in the field, where your camera is always around your neck and ready for action, and you need a camera bag essentially as an accessory bag for a lens, a flash, and film or digital cards, almost any small bag that has a shoulder strap, a zipper to keep out the dust, and a flap to repel rain can work.

Cameras

There are many options when choosing a camera system. The most popular camera choice is the SLR (single lens reflex) 35mm film or digital camera. The SLR camera allows you to see through the lens at the moment the photo is being taken. SLR cameras are compact and have many choices of lenses, portable flash, and other accessories. The advantages of SLR cameras over other types of cameras are that

The medium photo kit is the one I use the most. It is very light, about three pounds, and flexible. Although the setup pictured here is a digital camera, a 35mm film version weighs only a pound more. The medium kit will cover most situations, but you can add a portable flash, mini tripod, etc., for more versatility. This kit's two lenses cover 18-105mm in the 35mm format. The kit's wide-angle lens can be substituted with a tele-photo lens, such as a 70-300mm, as the situation demands, adding little difference in weight or bulk.

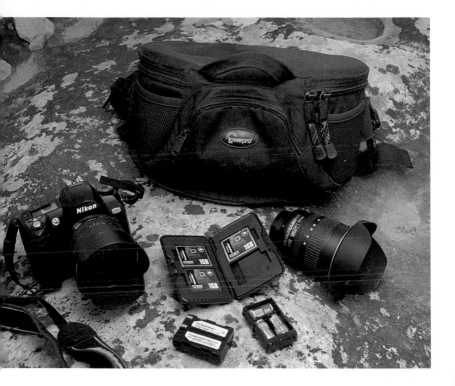

they can use interchangeable lenses, are equipped with motor drives that allow the camera to shoot photos in rapid succession, have sophisticated light metering, and have auto-focusing lenses. This technology can be very helpful in capturing action, the hallmark of adventure photography. Top-of-the-line professional SLR film and digital cameras usually have environmentally sealed bodies to protect against dust and moisture, a bonus for photographers traveling in harsh conditions. However, these cameras are often very expensive, with more features packed into a big, heavy body than the average photographer would use. The option is to purchase what is known as a prosumer SLR camera. These cameras are a few models below the top-of-the-line

Shown: Medium hip style bag with waist and shoulder strap (choose size to fit contents); SLR digital camera body with pop-up flash; 28-105 (35mm format equivalent) telephoto lens with hood; 18-35 (35mm format equivalent) wide-angle lens with hood; four memory cards; two spare batteries; camera brush; ccd/cmos sensor cleaning brush; pen and note pad.

pro camera but often have many of the same features, and they are less expensive and more compact. Other popular cameras are the small point-and-shoot cameras. These cameras are cheaper than SLRs and far more compact. The point-and-shoots' drawbacks are fixed lenses, shutter lag (a term in digital cameras for the

You can often keep your camera out and shooting on a cold snowy day with little more than a brush to keep the snow cleaned off your lens. Keep the brush handy, and you'll be ready to shoot at any moment.

delay, often more than a second, from when you take the photo and the camera actually captures the photo), and lower quality digital chips than SLRs. Some of the higher end digital and film point-and-shoot cameras can produce photos that equal the quality of an SLR, but then why not purchase the SLR? The point-and-shoot can be a cheap and compact option as a backup camera to the SLR. The digital point-and-shoot is an excellent choice as an underwater camera, as the underwater

housings for the point-and-shoots are a fraction of the cost of SLR housings.

Much has been written about digital versus film cameras; the arguments are usually in the same tone as the arguments between black-and-white photographers when color film was introduced, and large-format camera shooters when 35mm cameras gained popularity. The digital image is excellent and is the future for SLR photography. There will always be a place for film cameras, just as there is a place for black-and-white film and large-format cameras.

Today's digital cameras—even the non-pro versions—work well in the field. Their weak links, however, are power for the rechargeable battery, power for the heavy, bulky portable hard drives, which also run on rechargeable batteries, and the expensive and fragile memory cards. Of course these factors are only a concern on extended trips of a month or longer to a place where you have no access to electricity. If you plan to be hiking into remote areas and out shooting for extended periods of time with no access to power, you will have to consider this problem carefully.

Lenses

The zoom lens is the workhorse of outdoor adventure photography. Zoom lenses have excellent optics, and their greatest advantage is they allow you to change the perspective of what you see in front of you without having to move yourself an inch. When purchasing a lens, you will look at lenses with different focal lengths. The 50mm lens is considered the normal lens since its focal length of 50mm is roughly equal to our normal sight perspective.

Tip

Remember to keep your cameras clean. During times of blowing dust or sand, avoid changing film; or, with digital cameras, changing lenses. Wait until the storm has passed or open the camera in a clean sand- and dust-free environment indoors.

As you decrease the lens focal length from 50mm to 28mm, the angle of view becomes wider. Also, with the wide-angle lens the depth of field is greater. The 28mm is a standard wide-angle lens, but most professional photographers carry 18mm super-wide-angle lenses, which allow you to work in very cramped quarters and still capture a standing adult from just a couple of feet away. Wide-angle lenses are perfect for rock climbing and other sports where your movement is greatly restricted. On the other side of the focal length spectrum is the telephoto. If you increase the focal length number to 200mm, you have the standard for a telephoto lens that has a narrower perspective than normal. The wildlife photographer's standard telephoto is the 600mm. This is a tank of a lens that weighs about eight pounds. The standard choice for adventurers is a 70-300 zoom.

The large photo kit is the full professional kit. This system typically has one body and three to four big, fast 2.8 aperture zoom lenses. There might also be a specialty lens such as a 60mm macro or a 16mm fisheye. The kit still fits in a big hip bag with an attached daypack and will weigh ten 10 to 12 pounds. With this kit you are ready for any photo situation.

The next consideration with a lens is the f-stop. The rule with lenses is the lower the f-stop number—for example f/2.8 or 1.4—the better the quality and the heavier, bigger, and more expensive the lens. These so-called "fast" lenses have an expensive big chunk of optical glass for light to pass through. Professional photographers prefer these "fast" lenses because they have the highest-quality optics and are optimal for shooting in low-light conditions. The big opening in the "fast" lens operates on the same principle as a water faucet: the bigger the lens opening, the more light can pass through; the smaller the lens opening, the less light passes through. On the flip side, "slower" lenses with a higher f-stop number (f/4 or f/5.6) use smaller diameter glass optics and allow less light to pass through the lens barrel. The advantage of "slower" lenses is lower cost, smaller size, and less weight.

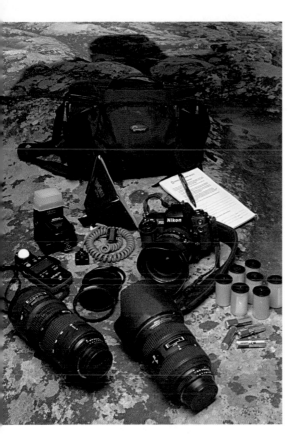

Shown: A large hipstyle bag with waist and shoulder strap; 35mm SLR camera; 17-35mm 2.8 lens; 28-70mm 2.8 lens; 70-200mm 2.8 lens (can substitute with a 80-400mm image stabilizer lens); camera flash with soft bounce attachment; flash meter; mini soft box; off-camera TTL cord for flash; filters, including: polarizer, 81B warming filter, 3-stop neutral density, and 2 stop split neutral density; extra batteries for camera and flash; eight rolls film minimum in camera bag; camera brush; model releases, pen, Sharpie, Ziploc bag to store shot film.

FOLLOWING PAGES: When out adventuring, you never know what you might come up against. If you pack a light camera kit, the camera won't get in the way of having fun.

The disadvantages of slower lenses are that they are not built as sturdily as the "fast" pro lenses, they do not work well in low-light conditions, and their optics are not as sharp as those of a "faster" lens. Some of the "slower" lenses have quite satisfactory sharpness. Read reviews about these slower lenses before you buy, and don't always believe the glossy ads that talk about pro quality for dirt cheap. The two most popular "fast" zoom lenses used by pro photographers are the wide-angle 17-35mm f/2.8 lens and the telephoto 70-200mm f/2.8 lens. There are many zoom lens combinations; my favorite compact, sharp, lightweight,

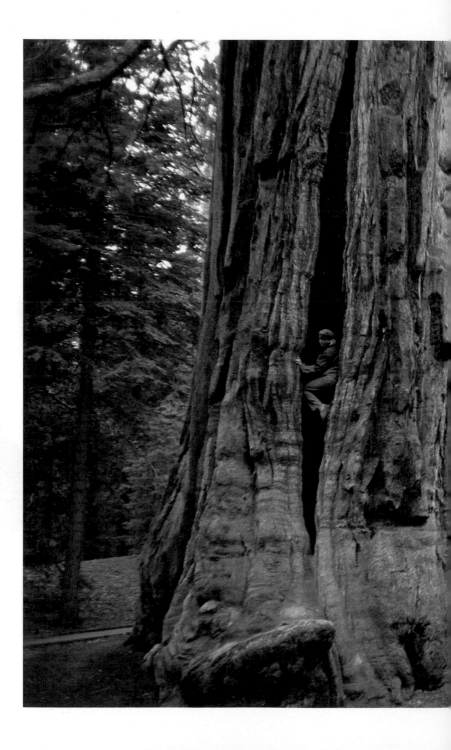

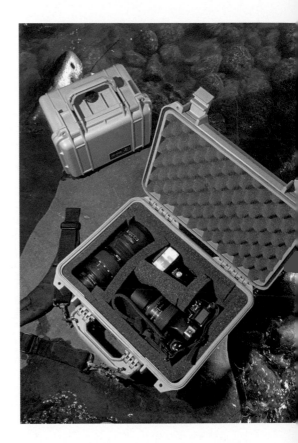

The water and dust-proof Pelican case comes in many sizes and is one of several brands of bombproof hard plastic foam-lined photo cases on the market. My Pelican case is fitted with a shoulder strap to keep my hands free when I get on and off a raft.

wide-angle one-lens-does-it-all is the 24-85mm zoom f/2.8-4. From a general all-purpose lens like this you can build your arsenal to include a 16 or 18mm super-wide fixed lens and a 75-300 or 70-400 image-stabilized telephoto. If all you want to carry is one lens, consider the 28-200 compact lens. This power horse does it all, from wide angle to an impressive telephoto.

When you buy a lens for a digital camera, remember that all SLR lenses are marked for the 35mm format. Most digital SLR cameras, except for a few high-end digital SLRs, have a smaller format chip size than standard 35mm

film. When the image from a 35mm lens is projected onto the smaller digital sensor, the sensor captures only the center portion of the image. To determine the correct lens angle of view in digital cameras, you can multiply the 35mm lens number by 1.5. This makes a 16mm lens into a 24mm lens. A 200mm lens becomes a 300mm lens. Camera manufacturers do make wide-angle zoom lenses specially designed for the smaller digital format; these lenses, however, do not work on the 35mm format cameras without serious vignetting.

Flash, Filter and Accessories

The portable flash is a very important accessory for outdoor photography. Sometimes you come across photo opportunities with great action and composition in locations you are just moving through, when you cannot wait for the good light, and may never visit again. Often in these situations you can make a memorable photo with the use of a flash. In the field I use a flash on many of my photos when I am shooting under a harsh midday light. When I am under a dark jungle canopy, I may use a flash for 95 percent of my photos. You should carry a flash and learn to use it.

With today's saturated film and digital medium that can be adjusted later for color balance, there is still a need for some basic filters. I always carry a few filters. My basic kit includes a polarizing filter, which is great for shooting around water to remove reflections or to darken the sky to dramatize clouds. I also carry an 81A or B warming filter to offset the cool blue light common in shadows and to warm the color of skin tones or rocks. I bring a split neutral-density filter in a 2-stop or

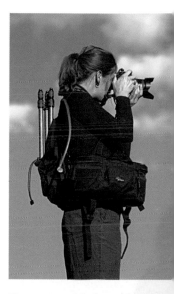

The camera hip bag with a waist and shoulder strap is the standard camera bag for adventure action photographers; a small camelback brand hydration pack can hold a light carbon fiber tripod, energy bars, water and rain jacket—all you'll need for a morning or evening outing from your base camp.

3-stop model. The split neutral filter, when held in front of the lens, can help knock down the light in the bright area of your photo frame. A typical situation might be photographing a mountain scene reflected in a lake where the reflected image may be two stops darker than the light on the mountains. A split neutral filter helps equalize the light without affecting the color, hence the term "neutral" filter.

Maintaining your equipment in the field is critical for camera operation on long trips or trips to humid tropics, deserts, or sub-zero areas. I give my cameras a complete cleaning if I have been shooting in rain or blowing sand.

Another item always in my case is a camera brush to clean dust and sand off my lenses. If you clean the inside of your film camera with a brush, you have to be careful about stray hairs in the camera. The sensors of digital cameras also need to be cleaned periodically, especially if you are shooting in desert areas with windblown dust and sand. There are several methods for cleaning your camera's

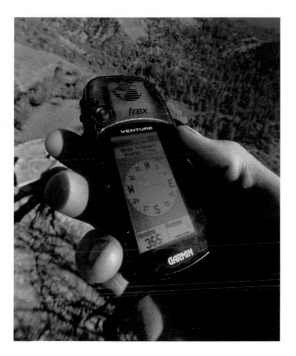

The GPS, or compass, which can pinpoint where the sun rises and sets, is a helpful tool for the photographer in the field.

sensor. The first option is to take the camera to a professional for cleaning. There are several products that can be used to clean the sensor. The two most popular are the methanol swab and the electrostatic brush. Cleaning the sensor is a delicate procedure that needs to be done with great care to avoid damaging the CMOS or CCD camera sensor.

I typically do not carry canned air because it is bulky. If you do use compressed air, be aware that sensitive internal parts of a camera can be damaged by the high-pressure blast. Also, compressed air can freeze in contact with outside air, which can damage lens coatings and digital camera sensors.

You should always have spare batteries and spare rolls of film or digital cards with you when out shooting. I also make sure to bring energy bars and water to keep my energy levels up.

GORDON WILTSIE
Consummate Adventurer

Mike Sharp

GORDON WILTSIE grew up in Bishop, California, a mountain town nestled between the Sierra and White Mountains. By his late teens Wiltsie was an accomplished mountaineer, climber, and budding photographer. Wiltsie calls himself a self-taught photographer, but living where he did, below one of America's most beautiful mountain ranges, he could not help but meet and be inspired by the many leading outdoor and landscape photographers who traveled through his area.

Wiltsie's early photo career breaks began with a 1975 photo essay in the magazine *Ascent,* which established his reputation with the outdoor adventure audience; then an article the following year in *Outside* magazine presented his name to an even wider readership. Subsequently, his many feature stories for *National Geographic,* including several cover stories, have established his worldwide reputation as the consummate expedition and adventure photographer. Wiltsie began publishing his adventure photography in national magazines while he was still a college student, and the popularity and ready market of adven-

During an assignment to the Cordillera Sarmiento, an unexplored mountain range at the southern tip of Chile, Wiltsie's team climbed one of the highest peaks in the region. Noticing an enticing snow spire in the distance, Wiltsie instantly realized how exciting it would look with climbers on its summit.

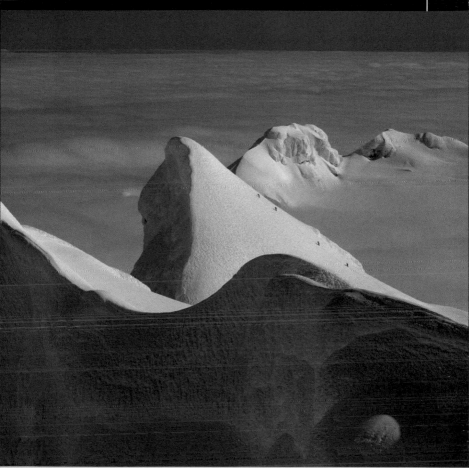

While his companions rushed off to ascend the "Gremlin's Cap," Wiltsie prayed that the ice inside the elements of his 80-200mm zoom lens would thaw before they reached the top. In the interim, he grabbed this image with a 50mm lens, setting his friends into the grand context of the other-worldly environment.

ture photography steered him away from his real passion, which is cultural subjects.

In pursuing his photography degree from University of California, Santa Cruz, Gordon wrote his own course work for an extended stay in Nepal, where his cultural studies included learning the Nepali, Hindi, and Tibetan languages. "My studies in Nepal began my lifelong fascination and pursuit to photograph vanishing cultures," he says. Gordon's time in Nepal also began his long involvement with guiding and photographing in the Himalaya. Recalls Gordon, "Early in my career I thought my photographic focus and specialty

When Gordon first encountered this 80-year-old Nepali rice farmer while trekking around Mount Annapurna in 1977, the old man asked him not to take a picture because he was wearing ragged clothes and wouldn't look his best. Nevertheless, they were trapped together in a trailside shelter by a monsoon downpour, and he warmed up as Wiltsie and his wife, Meredith, chatted with him in Nepali. Finally, as the clouds parted, he agreed to be photographed. "Take two," he said, "and please send one to me." Two years later, Gordon delivered it back to his village.

would be primarily the Himalayan countries, but then I started guiding and photographing in Antarctica, which led to a couple of stories there for *National Geographic*. Other assignments sent me to the Andes, the Canadian Arctic, and China." Gordon's Antarctica experience eventually led to a cover story in the February 1998 *National Geographic* magazine about a climbing expedition to the little-known Queen Maud Land.

Wiltsie has been involved in more than a hundred expeditions outside of the United States. His area of specialty is mountains and adventure, but lately he has come full circle and is again focusing his camera on cultural stories and mountain people. Recent stories include the recovery of mummies in the Peruvian Andes and the winter migration of the Darhad people of northern Mongolia. Gordon's work ethic on assignment has him up before dawn, and he doesn't call it quits until well after dark. The average assignment may last five to seven weeks. When on a shoot, Wiltsie says, "keep the story in mind. Maintain a shot list of visual pieces that add up to a coverage that is greater than any single image. Think wide, medium, and close-up. It's easy to focus on making every picture a calendar image and miss out on less obvious things that are happening behind the scenes."

Besides getting the photos, Wiltsie also has to work on fitting in with and being accepted by team members. Wiltsie's expedition philosophy is simple: "Be careful not to influence the course of the expedition. Work to fit into the group by helping with chores, carrying loads, and doing other daily tasks. The best tactic for the photographer is to work hard to blend in." Communicating your objectives to the team is

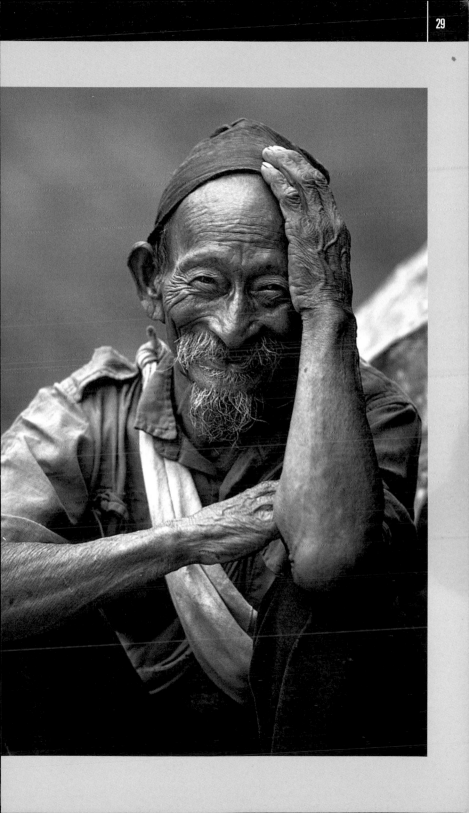

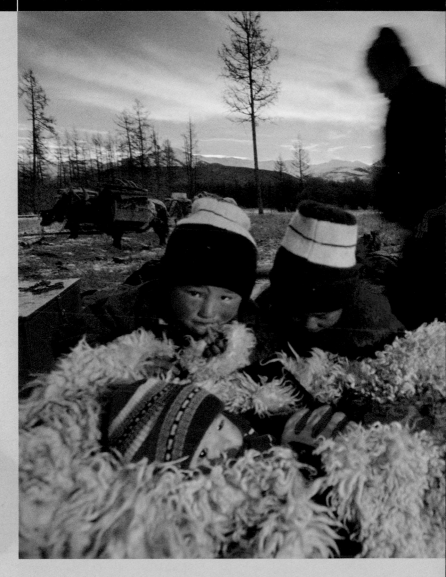

important: "Work out your photo needs in advance with the team leader and every single member of the expedition. Explain what they need to do to help you get the photos you need. If part of the team resents your presence, your experience with the trip may become miserable—even life threatening.

"Your shooting style should not be intrusive. When photographing people you do not

During an assignment covering the semi-annual migration of the Darhad people in northern Mongolia, Wiltsie's translator alerted him to an adorable picture. To balance the dark fore-ground with the much-brighter sunrise, he used a 2-stop graduat-ed neutral density fil-ter on his 20mm lens, and then rigged two flashes with amber-colored cellophane. He put one on the camera, set manually to deliver minimal light, and another off-camera to the right, which he also set manually to be the "key" light for his foreground. Once the flashes were set up, he waited patiently until everyone relaxed and the scene was able to unfold naturally.

know, either ask permission or make it so fast and painless (followed by a smile) that they either do not know you shot a photo or do not care. Asking permission is often deadly for spontaneity, but works beautifully if you can spend enough time together that your subject can relax. Bottom line, it is essential to be extremely sensitive, and if in doubt, do not shoot."

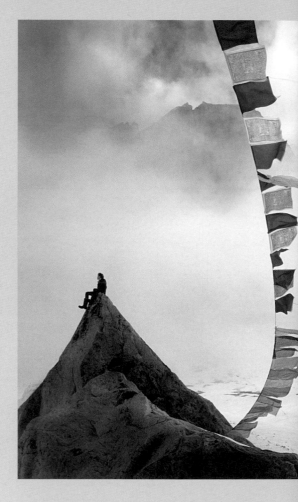

Before the ascent of a 4,000-foot cliff on Canada's remote Baffin Island, team member Alex Lowe stretched a string of Tibetan Buddhist prayer flags to bless the base camp. Afterward, as Lowe sat atop a boulder, Wiltsie used a 20mm lens to emphasize the sweep of the flags, moving subtly from side to side to adjust its arc and the alignment of shapes—a framing that includes many triangles, one of his favorite compositional elements.

Often photographers are too trusting of their cameras, relinquishing too much control to its automatic functions, says Wiltsie. "In this age of automatic cameras, anyone can take a modestly decent picture. To rise above you have to be a technical master." He adds, "Be fast and mobile. No one wants to wait around while you spend time on focus and exposure. They especially hate it if you always have to stop to take your camera out of your pack. What's important is to be there with your eyes and mind alert and

your camera ready. Look for the moments: peak action; revealing facial expressions; personal interactions; or unusual, fleeting light."

Wiltsie consistently produces photos that look natural and unaffected by camera flash or technique; however, he often uses a portable flash. He believes every photographer should master the use of flash and bounce lighting. These are regularly needed to bring out details in shadowy areas, to create a sparkle in someone's eyes, or to create truer color in miserable weather conditions, all of which can seldom be accomplished with automatic flash settings. For most of the photos reproduced here, Wiltsie relied on a simple, lightweight camera setup and small battery-operated strobes.

Gordon Wiltsie Tips

- Make yourself intimately knowledgeable about any activity, sport, or environment you want to photograph. If you're not a climber or a skier, for example, chances are you won't photograph these activities well. You're also unlikely to create much that's visually new or different if you shoot something that you haven't researched.

- Keep abreast of what other adventure photographers are doing. What might have been leading-edge imagery a few years ago has likely been copied so much that it isn't novel anymore.

- Adventure photography is inherently risky, but don't take stupid chances to get a picture.

- Become part of the team. Do your share of any expeditional duties. Make yourself an insider, not someone on the outside, looking in.

- Always keep your camera right at hand. Some of the best moments come completely by surprise.

- Look for unusual angles, frames, and perspectives. Often just a part of a person or scene will communicate the whole. Consider, for example, advertising for Marlboro cigarettes. Viewers of these ads can see just a belt buckle or a bridle hung over a fence and envision a cowboy and his smokes.

- Don't forget to have fun. Choose projects that are close to your own heart and abilities so that you can enjoy them.

Composition

THERE ARE NO SILVER BULLETS for nailing the
perfect composition. For as many situations
where you can apply a rule to a photo compo-
sition, there are others where you can break
the rules and still make the photo work. In
trying to understand composition it's helpful
to pick up books by your favorite photogra-
phers or artists and analyze how the scenes
are composed. When you see a photo you like,
ask yourself the following questions: What do
I like about the photo? What do I dislike about
it? How was subject framed? Is the scene clut-
tered or simple? How does the photographer
use composition to convey feeling or emotion?
How are elements of color, shape, and texture
used to highlight the main subject and lessen
the role of minor or supporting elements in
the photo? If you are attentive, you will notice
how you can compose everyday scenes in a
variety of ways to illustrate either a simple
theme or a complex idea or story.

Stop, Compose, Shoot, and Keep Shooting

A fellow photographer once told me that if a
photo is worth shooting once it's worth shoot-
ing a dozen times. What the photographer
meant by this is simple—it's first about

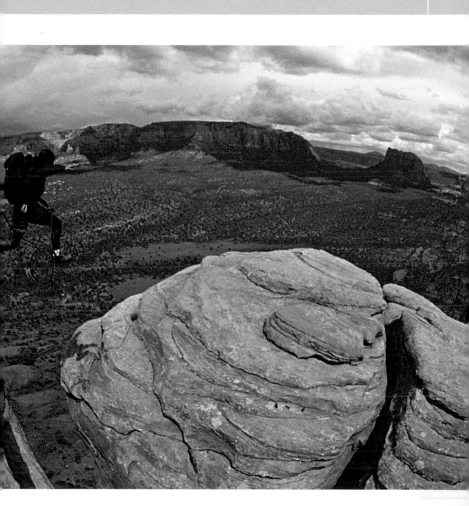

recognizing a great shot. Follow your instincts. Making great photos is an intuitive process. If you see something that makes you put the camera to your eye, look closely at the elements that make up the photo. If you were motivated to shoot that one shot, then the scene is worth studying in more depth. Don't be afraid to shoot a few dozen shots of something or someone that appeals to your photographic eye. The rules we'll discuss on the following pages are things to consider that can help you improve on that original shot. Ask

This photo was carefully composed. The main subject is the person jumping, but the composition includes a dramatic landscape of rock, a stormy sky, and the air beneath the jumper's feet. These elements add drama to the central action.

yourself what drew you to the photo in the first place. Is the photo a simple composition, maybe a pretty sunset with a splash of color, or are there multiple elements that come together to tell a story? Ask yourself whether you're trying to communicate a single idea or capture a scene that tells a bigger story. A photo can touch emotional triggers, it may be a metaphor, or it can be symbolic. Often our eyes are drawn to a small, singular element in a big scene. Watch out! The most common mistake photographers make is not framing tight enough around the main subject of the photo. So move in close to whatever it is that caught your eye. Observe what is going on

Here a natural window gives dramatic framing to a photo. Placing a subject inside a natural frame is an effective composition technique. Canyon walls, a tent door opening, waterfall ice, or trees are other "windows" that can be used to frame a photo.

around the main subject of your shot. How do these minor elements relate to the main subject in the photo? If they are unimportant to the main subject of your photo, recompose your shot to remove the unwanted elements. Before you take a shot, literally look into the corners of your framed photo. Make sure all the parts in your frame are wanted in the photo. Fill your camera frame only with items that contribute to your photo. Do not be afraid to experiment and try different compositions with the same scene. This is a form of editing. Try both vertical and horizontal compositions. As you compose your shot, remind yourself of what you are trying to say with the photo. Again, this may be as simple as a dramatic splash of color or action, or it may be a more complex picture or story. A successful photo is one that communicates your idea to the viewer. Ask yourself if your photo will be able to communicate the emotion and feelings that you experience at that moment.

> **Tip**
>
> Don't always use the camera rectangle to frame your picture. Look for natural frames, such as an arch or the shaded walls of a canyon. A frame can be a dramatic device to enhance your subject.

Color

At first it may seem odd to place color in a chapter about composition. But color is a design element just like any other compositional tool discussed in this chapter. Color is especially relevant for sports and adventure photography. How you compose color and how you play colors off one another in a photo can either heighten the feeling of action or have the effect of making a scene more tranquil.

People are drawn to certain colors for many reasons; often it is just because they like a particular color. In many cases the selection of color based on personal preferences can result in garish combinations. Look at the text and

background color combinations used on Web sites to see proof of this. The way color is used is an important element of the photo's overall composition. A simple working knowledge of how color works with or against other colors will give you more control over the emotion expressed in your photo.

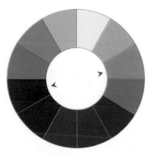

Complementary colors

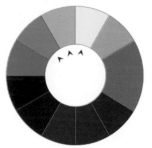

Analogous colors

To understand color, it is helpful to look at a color wheel. The wheel above is a RYB (red, yellow, blue) color model. This model is traditionally used by artists; there are different color systems for computer work and printing purposes. Look at the color wheel and you will see that the color orange sits opposite the color blue. Colors that are directly across from each other on the wheel are called complementary colors. Look at the color wheel and you will see other complementary colors. For example, red and green are complementary, as are violet

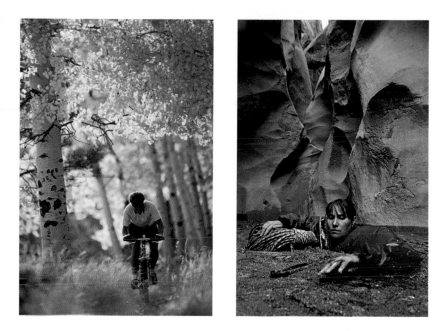

Colors can be used to imply action or emotion. The colors of the bike rider and the aspens are analogous, giving a feeling of serenity. The active red of the canyon swimmer's suit heightens the emotion and impact of the photo.

and yellow. Complementary colors used together play off each other, and the contrast between them has the effect of bringing both of them to their most dynamic and vibrant level. If you want the color red in your photo to radiate, place the red in proximity to a complementary color, such as green or blue. The dynamic nature of complementary colors can heighten the feeling of action. Imagine a mountain biker dressed in yellow against the green of a forest background; now imagine the same scene if the rider were wearing blue.

The colors that sit next to each other on the color wheel are called analogous colors. Examples are red and orange, or blue and green. These colors do not contrast with each

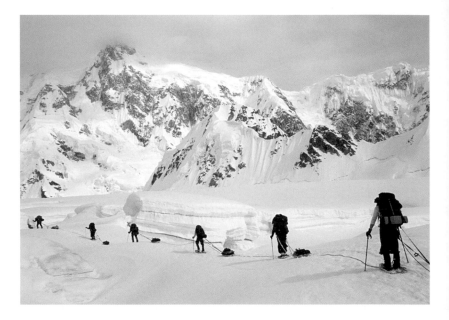

A team of climbers roped together (above) serves as a leading line to draw the viewer's eye into the scene. In the photo below, the leading line is the bridge span, which leads the eye from left to right and front to back.

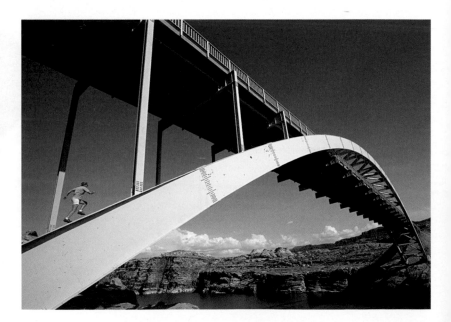

other and can be used to express serenity; the viewer feels calm and comfortable. Knowing how color works with or against other colors gives you more control in your composition.

Leading Lines

To highlight or lead the viewer's eye to the main subject in a photo, photographers often use a leading line. This may be as simple as a rope in the foreground leading to a climber in the upper frame of the photo. When you are shooting a sports scene that is an overall view of the natural environment, look for natural leading lines, such as the curve of a river, which moves the viewer's eye into the scene to a raft in the distant scene. In Western cultures, people read text from left to right and from the top of the page to the bottom of the page. Our eyes have been trained to look this way since we first began reading as children. A leading line that moves from the left side of the frame to the right side of the frame follows a predictable and expected pattern.

However, if the leading line in a photo originates from the right side of a frame and draws the viewer to the left, the movement is subtly unnatural. It's helpful to be aware of this trick of the eye. Awareness of these and other patterns can help you tweak the feeling that your photo elicits from the viewer. You can heighten the drama by playing with how and where the leading line moves the viewer's eye. Ask yourself if the leading line is going with the natural flow or against the flow. How you use the leading line can do more than simply draw the viewer's eye to the subject; it can also contribute to the action and emotion of the photo.

Tip

Always keep an eye on camera frame numbers and battery levels, and make sure your camera is set for rapid shooting. If you're just a few frames from the end of a roll of film, or from filling your digital memory card, change it out if you anticipate any action.

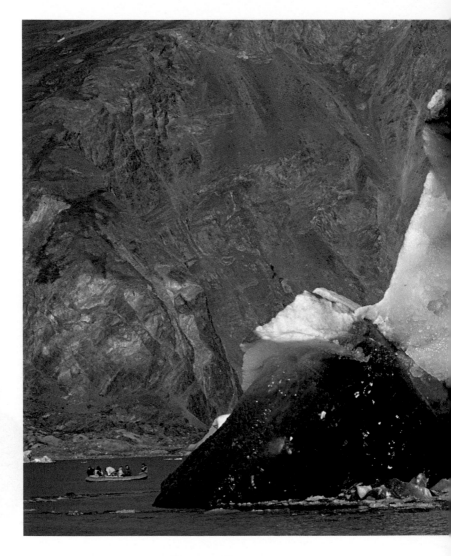

Perspective

When shooting in the outdoors, pay particular attention to perspective. Perspective is how you relate the subject to the background or foreground in your one-dimensional composition. This relationship can be a simple comparative relationship that communicates

Place your hand over the raft and see how the absence of the small raft completely changes the size of the iceberg. When shooting in the vast, often abstract landscapes of the mountains, oceans, and deserts, look for people or familiar objects in the landscape to help the viewer grasp the scale of the landscape.

how big, tall, or dramatic a landscape, river rapid, or climbing wall appears. Perspective can be used to exaggerate and dramatize this relationship. There are a few simple rules to control and change a perspective. First, objects closer to the lens appear bigger than those farther from the lens. The second is a frame-size relationship: the smaller the

subject is in the photo frame, the larger the surrounding background is in relationship to the tiny subject. Third, the type of lens you use can also change perspective. If you use a fixed lens and move closer to the foreground subject, the background will remain the same. If, however, you use a zoom lens and

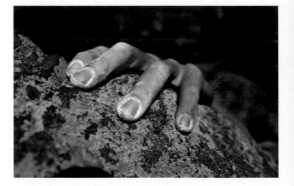

The use of selective focus, using a low aperture number and minimum depth of field, brings the viewer's eye directly to the hand. With selective focus, the background clutter behind the rock becomes out of focus and does not distract from the hand.

zoom in on the foreground subject, the background will also be magnified.

Selective Focus

Another primary tool for composition is focus and use of the camera's aperture. Selective focus is a good tool for dramatizing the main subject and separating it from the background. The aperture you choose for selective focus should be a low number, such as f/4, that allows for what is called a shallow depth of field. The easiest way to use selective focus with a medium- to wide-angle lens is to move close to the main subject and focus on it. If it is not possible to focus on the main subject this way, use a telephoto or zoom lens. Both of these methods will isolate the subject from the background by allowing the background and foreground to fall out of the zone of focus.

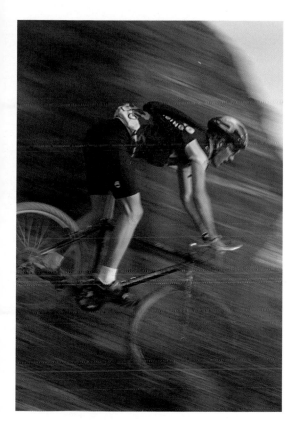

When shooting moving subjects, blur panning with a slow shutter speed can isolate the subject from the cluttered background, as well as give the subject a sense of motion. The front and back tilts of the large-format camera help keep image sharpness from foreground to horizon.

With a telephoto lens you can use an aperture as high as f/5.6 and still have the background and foreground out of focus. Experiment, and see what works best.

Shutter Speed and Motion Blur

Another way to highlight a subject and de-emphasize the background or vice versa is blurring. This technique is used primarily to give a sense of motion in an action photo. There are two types of motion blur, and for both you will be using a slow shutter speed. Begin by using 1/30 of a second, and then try slower and faster shutter speeds until you like

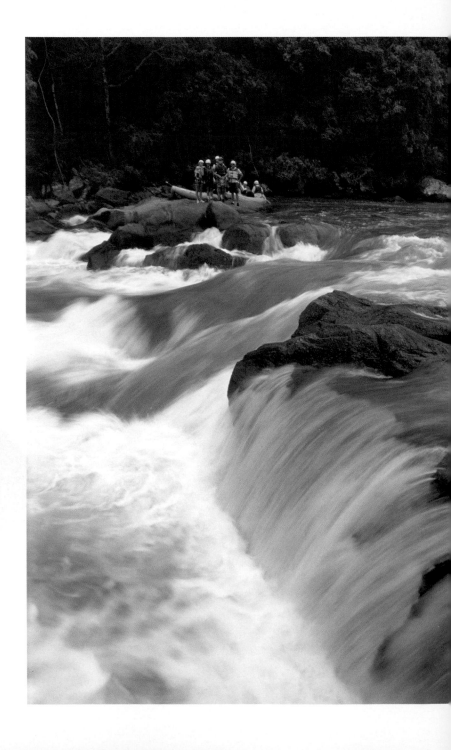

the results. There are a couple of ways to capture motion. The first is by holding your camera steady and allowing the action—a bike, for example—to move past the lens. Adjust the shutter speed according to how fast the object moves across the field of view. You will notice that the closer the moving object is to the lens, the faster it moves through the frame. Also note that if the object is moving toward the camera and not across the field of view, the appearance of motion is even further slowed, meaning you can use an even slower shutter speed to blur the movement. Knowing the different relative speeds of objects coming toward the camera or across the frame is handy when you need to shoot a moving object. For instance, if you want to use a slower shutter speed and you do not want blur, have the object move toward the camera rather than across the camera's field of view.

The next way to blur motion is by doing what is called pan blurring. Here, you are trying to keep the object that is moving somewhat sharp, while the fixed surroundings are in motion. To use this technique you will follow the moving object with your camera as it moves past you. This technique takes some experimenting to perfect, but the results can be amazing. Start by using 1/30 of a second, and then experiment by trying slower shutter speeds. If the moving object is moving in a smooth, consistent manner, you can reduce the shutter speed even more. When I photograph kayakers on a play wave, or a road bike on a smooth road, I often set my shutter speed as slow as 1/4 of a second hand-held, while firing off a burst of shots with my motor drive set at its highest speed. Remember that if the object you are photographing is moving in any

To capture this river rapid, I braced the camera with a tripod for a 1/8-second exposure. The rafters scouting the rapids give the river perspective and lend emotional suspense to the photo.

direction other than in the motion of your pan, the moving object will not be perfectly sharp. For example, a mountain biker may be bouncing up and down as well as moving across your field of view as he rides down a trail. In this case, you could try to find a less bumpy section of trail. Don't be afraid to use a motor drive when shooting. You can also shoot pan blurs from one moving object to another, such as from a bike or a moving car. But in these cases you now are less likely to get a sharp photo because of the added and often unequal movement of two objects. An object flying through the air, such as a skier or diver, is an excellent subject for a pan blur, but you will need to mimic the arc of the flight to keep the moving subject sharp.

Rule of Thirds

When you look at various favorite photos, you may notice that the photographer has placed the main elements of the photo, such as the sky and the foreground, into a pleasing balance, but the balance is not 50/50, nor is the main subject smack in the middle of the photo. The sky may be one-third of the photo, while the foreground makes up the remaining two-thirds of the scene; the sun is often off-center to the left or right of the center of the frame. This "balance" is called the rule of thirds. Dividing a picture frame into thirds is preferred because it lends a more active, less stagnant appearance to the main elements of the picture and their relationship to each other. It is important to know the rules and apply them; however, you also need to be ready to break them if you think it will help your photo deliver its message with more emotion and directness.

The rule of thirds is an effective way to create an active balance in a composition. If objects are centered perfectly in the frame, the composition is likely to be static.

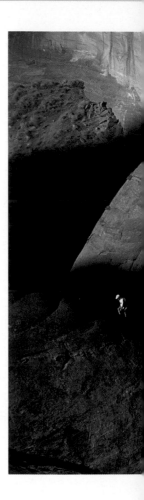

Light and Shadow

A GENERAL RULE is that your eye is drawn to the lightest part of a photo. Adventure and outdoor sports photography is typically shot in a journalistic style as the events unfold. This means you will often have no control over where and at what time of day you will be shooting. You need to understand light and be sensitive to how the available light can best fit your needs. Often this means just knowing the best place to position yourself before you begin shooting.

I move around and change my position to determine how to light a subject, which helps me find the best position and tells me when I need to adjust for bad light. Film and digital images are not as sensitive to light as our eyes are. We call this sensitivity the latitude that film "sees." If you meter the average daylight scene from the highlights to the shadows, you will see a range of about six aperture stops. But the latitude of most film and digital images is only about one to three stops. So while the human eye has far greater latitude to see than film, and can see detail that is both lighted and in shadow, the picture image cannot. For this reason, we need to always prioritize our exposure for the light and dark areas in the scene. With color film and digital images we tend to meter for highlight areas and allow darker areas simply to fade to black. Digital images allow for good

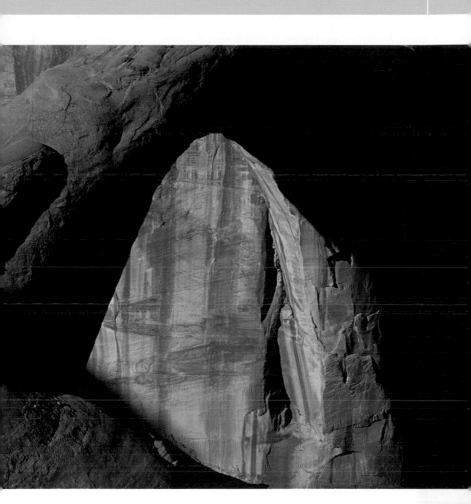

shadow detail but have an even narrower latitude of acceptable exposure for highlights than film; this means your metering has to be right on. With either film or digital, if we metered for shadow areas, the lighted areas would become overexposed and the photo would be wasted.

It's important to understand the different types of light. There are three major characteristic types of outdoor light: direct hard light, such as open sun or electronic flash; modified light, which is filtered or defused; and reflected light.

The sunlit figure is small, but because he is against a shadowed background he jumps from the picture and anchors this otherwise surreal landscape of the Rainbow Bridge in Arizona.

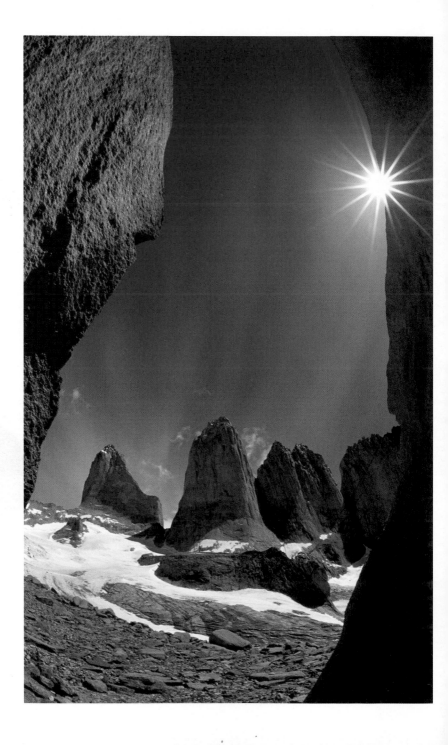

Let's look at hard light first. Hard light is light that casts a distinct shadow. Hard light sources tend to be small points of light relative to the whole scene. Examples of what I call "penlights" of light are the sun, high in a clear sky, or a small portable flash. When you look at a scene, observe where the light is in relation to the direction you are photographing. If the sun is behind you and the scene is in front of you, this angle will produce flat light because no shadows are cast left or right of your subject. In most cases, you will want shadows so as to add contrast and depth to your photo. Contrast will give texture and dimension to your subject and helps separate your main subject from the background scenery.

To better understand how contrast works, try this experiment outside on a clear day. As a subject, use a friend or any freestanding object, a tree, for example. Look at your friend or object with the sun directly behind you. You may have to try this in the late morning or evening so the sun is low enough. Now, as you walk around the person or object, notice the shadows as you move to a 45-degree angle to the sun. See how the shadows help to pull the lighted subject from the background and give texture and relief to your subject. The direction of the light falling on your subject is an important consideration that can give dramatic effect. Before you take a photo, observe the position of the light in your scene. As you change your position in relation to the light and the subject, will the shadows help to enhance the scene and make it more two-dimensional? In bright sun, notice whether the subject you want to shoot is in the light or in the shadows. If your main subject is in the shadows, will the lighted areas of the scene

The sun in this mountain landscape radiates like a star. This effect is achieved by using a tiny aperture, such as f/16, on your lens. You should never look directly at the sun with a camera, not even if you have dark filters on the lens or are wearing sunglasses. I composed this photo with my hand in front of the lens to block the sun and with the camera fixed on a tripod. When I had the composition ready, I removed my hand and shot the photo.

draw your eye away from it? Often you can change your position in order to place your subject against a more suitable background. You can use this same strategy to place the lighted subject in your camera frame against a dark or shadowed background. Or you can silhouette a dark subject against a lighted background. The use of light and shadow is critical when you are shooting in less than optimal light conditions, which is often the case when you're outside all day shooting an adventure.

The fog gives this photo a feeling of mystery as shapes and trees disappear the farther they are from the camera. Meter carefully in fog, as the white mist will tend to underexpose your scene.

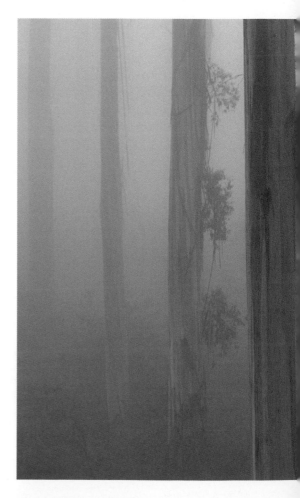

Light Modifiers: Natural Light Filter, Diffusion, and Reflection

Some of the most stunning photos are made when harsh direct light has been modified. Outside, the light of the sun can be modified and affected in many ways. The three basic ways are by filtering, diffusion, and reflection. A filter is simply something that is placed in front of the light to change its color or intensity.

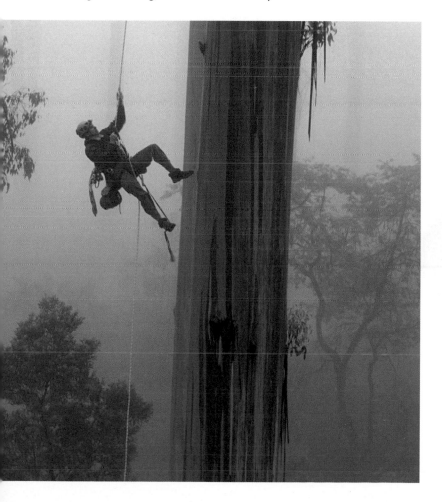

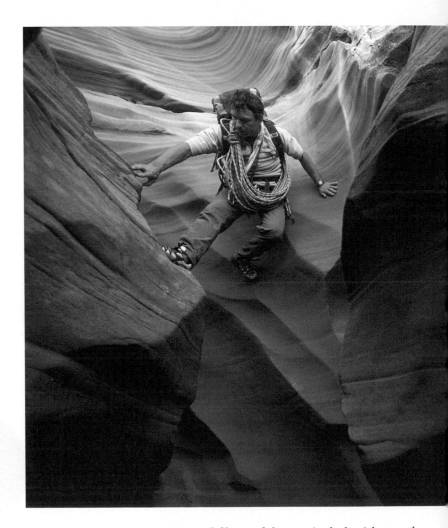

Natural filters of the sun include airborne dust and smoke, while examples of natural diffusion filters are clouds, fog, and haze. If I have my choice for the best light, I will shoot when the sun is low on the horizon. At sunrise or sunset, the hard light of the sun is softer because it is diffused and filtered as it passes through the less clear air (caused by dust, humidity, pollution, or all three) near the Earth's horizon. This dirty air acts as a filter to

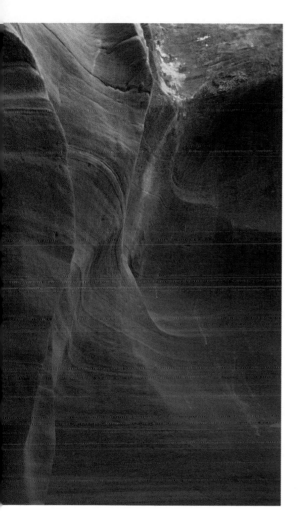

Slot canyons have some of the most pleasing warm light found anywhere. Because of the dim light in these deep canyons, a tripod is a must, and a wide-angle lens works best in these narrow places. This photo was taken with a 14mm lens and a shutter speed of 1/2 second.

the otherwise clean white light of an afternoon sun. It is the sunlight being filtered that gives you the warm hues you see beginning an hour before sunset or the first hour during sunrise. You will see the same warm colors when the sun is filtered by smoke or haze from a fire, pollution, or dust blown by wind.

Another type of filter is diffusion; this comes in the form of fog or clouds. When light is defused, the hard shadows on the

Tip

Keep your flash close at hand. Just a light touch of electronic flash can add a sparkle to a person's eye or pump up color in a drab scene.

ground become less distinct. Diffused or soft light is often called beauty light. This is some of the best-quality light for taking portraits or for shooting in a situation where you don't want hard shadows. Typically fog and mist develop when a cool air mass meets a warmer mass, often around a body of water. For this reason, cool mornings following a storm or other temperature change are the most likely times for fog to occur and the best time of day to capture interesting lighting effects.

Reflected light is something always to be on the lookout for. Reflected light tends to have softer qualities than direct light, and reflected light will take on the color of the surface it is reflected from. Look around when shooting rock climbing or canyoneering; in these places you often have situations where the sun is reflecting off a wall into the shadows. This reflected light could be a soft warm color depending on the color of the wall. When I am shooting canyoneering in the red sandstone slot canyons of Utah or Arizona, 95 percent of my photos utilize reflected light. Snow, sand, and even a hillside of dry grass are great natural sun reflectors. Look at how reflected light will fill shadowed areas. Of all the light modifiers, reflected light is often the most subtle.

You need to be aware of other naturally occurring filters that can affect the quality of your light. Wherever you are in nature, look above and around you and see if the sun is passing through or being reflected by anything. Sometimes the affected light can be pleasing, and at other times horrible. Shooting under a jungle canopy is like shooting under a big green filter. Green jungle light is perfect for lighting the jungle foliage, but not for photographing people. I correct the light by using my warming

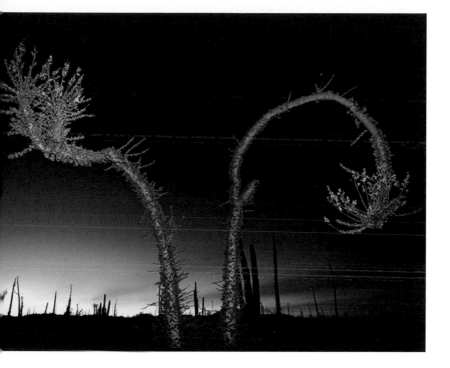

filters or flash. If the people are far enough away that the light on their skin will not be noticeable, I skip the flash. If I am shooting with sunlight streaming through a plastic canopy or a tent, I look to see that the fabric is not blue or green. If it is, then I will plan to use a flash to light the person. Shooting under warmer colors, such as orange or yellow, is better for skin tones. On a clear day the blue sky can act as a giant reflector. This becomes very apparent when shooting in full shadow. The blue cast in the shadows can be corrected by using a warming filter, either an 81A or 81B, on your lens.

During the last moments of sunset, a portable flash made this shot happen when nothing else would. I set the flash for full-power illumination on the branches of a boojum tree, and spot-metered the light on the horizon for the correct exposure.

Outdoor Flash

The portable camera flash is a critical tool for the adventure photographer. When you're

outside and the action is happening at all
hours of the day under every lighting situa-
tion, a flash can be a lifesaver. Used in the right
manner, a portable flash can be used to light
critical parts of a scene, and with practice it
can be a subtle but important addition to your
photography. It's obvious to use flash when
there is not enough light for a proper photo
exposure. The difficulty of using flash arises
when mixing natural light, also called ambient
light, with a flash; this is called fill-flash light-
ing. Since the human eye is far more sensitive
to light than are film and the digital image, it
takes some practice to recognize when fill flash
is needed. When using a flash we are just com-
pensating for the inability of our camera
medium to "see" into dark shadows or to dis-
cern colors and detail in flat or dim light.

Knowing when best to use a flash comes
with experimenting. There are two basic types
of flash use, full-power flash and fill flash. Full-
power flash is used when you want to light an
entire scene uniformly. Fill flash is used to fill
shadows with light. Learning fill flash is a little
part logic and a little part Zen. With some
experimenting you'll be using your portable
flash as if it were a magic light wand. Every
flash comes with a manual; look this over care-
fully. To accomplish fill flash you will need a
flash with an adjustable power setting in either
the auto or manual mode.

A mastery of fill flash is accomplished when
the viewer of the finished picture cannot see
that a flash was used. To achieve this result,
you will need to override the auto control on
your dedicated flash and reduce the power of
your flash. A dedicated flash means that the
flash, lens, and camera can communicate with
each another to match aperture number for

the correct flash setting. When you set your camera meter for ambient light, the flash will adjust its setting to allow for a full-power flash exposure. For fill-flash lighting, however, you will underpower the flash.

In the auto or TTL setting, the flash has a control to reduce the power output of the flash. Most flashes will reduce power from full power to three stops or more, usually in 1/3- or 1/2-stop increments. For most fill-lighting situations, a −1.7 seems to work well. If the shadow you are trying to fill is quite dark— the shadow under a hat brim in the middle of the day, for example—try using more light power by increasing the dial to 1. If you photograph people wearing hats, remember to direct the flash so the light hitting the brim of the hat does not cast a shadow on the subject's face. If you are looking for very subtle fill lighting, experiment using even lower settings. Many professional photographers shoot fill-flash shots by setting the flash manually. This is simpler than it sounds. By setting your flash manually you become more aware of the correlation between the ambient natural light and the light from your portable flash. Don't be afraid to learn how to power down your flash manually.

Tip

Cameras and flashes have complex program modes, so always travel with a copy of the instruction manual. These technical manuals are usually in several languages; copy only one language to save weight and bulk.

Off-Camera Flash

To give your flash work more versatility, try using an off-camera flash cord or a wireless or infrared flash trigger. Typically, off-camera flash is used to avoid direct, flat light and to allow a more pleasing side lighting Instead of creating a large shadow behind the subject, the shadow will fall to the left or right of the subject, which is less distracting. Off-camera flash

can also be used as a spotlight when the zoom function on the flash is used. First set the zoom function; if you are shooting with a 28mm lens set the zoom to 85mm. This will effectively light only a portion of your photo. Before taking the shot, underexpose the ambient light and then direct the flash to light only the main subject. Off-camera flash can also be an asset when there are branches or other objects between you and the subject. If you use an on-camera flash, the branches or objects in the foreground will be burned out. The off-camera flash can be a hassle to juggle, but just put it in a jacket pocket or over your shoulder so it's ready to use when needed.

I used a directional flash—in this case an on-camera flash—swiveled to the right to illuminate the pictographs while leaving the hiker silhouetted.

Flash Blur

Flash blur is using your camera on a slow shutter speed, then allowing your flash to freeze the

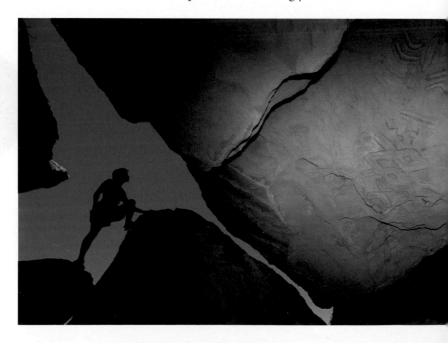

Flash-blur technique—using a portable on-camera flash with a slow shutter speed—has kept the subject walking sharp while the surrounding trees blur with action and movement.

action in the frame. Typically this is used only when the ambient light is very low. The typical shutter speed may be around 1/8 of a second. Most electronic flashes have a control for front-curtain and rear-curtain sync. For action shots you will want to set your camera to rear-curtain sync. The rear-curtain sync will allow the camera to expose the action, and just before the exposure ends the flash will fire. The result is a blur behind the flash-frozen subject. A helpful trick to flash-blur photos is to place the subject in front of a dark background. To add more drama, set your flash to full power, and underexpose the background by one stop.

CARSTEN PETER
Pushing Limits

Carsten Peter

IT'S OFTEN SURPRISING the route photographers find to pursue their photo specialties. It's a fact that today all of the world's highest mountains have been climbed, the darkest jungles penetrated, and both Poles fully explored. With the passing of the golden age of geographic discovery, many people expected this also meant the eclipse of exploration photography.

German photographer Carsten Peter did not set out to prove them wrong, but he has accomplished just that. Peter specializes in photographing in the world's most wild and volatile environments. He is best known for his extreme science photography, such as shooting inside active volcanoes, or getting closer to a tornado than any photographer before him.

Some of his tamer assignments include a 1,500-mile camel trek through the empty quarter of the Sahara, and exploring ice caves in the glaciers below Mount Blanc, France. Peter's premise for all of his expeditions is the question: Will the location offer me a glimpse into places few people have ever seen?

Rappelling down 1,500-foot (450 m) fragile vertical crater walls, Peter's team managed to get incredibly close to the vent and an active lava lake in the crater of Marum on Ambrym island in Vanuatu. Here in the zone of earthquakes and volcanic activity, there

was constant danger of rockfall. Down in the active crater, the acid gases caused malfunction of the equipment; even the glass of the lenses was attacked by fluoride acids. To get this image, it took 55 porters to carry all the ropes, climbing equipment, and other materials up the mountain.

Peter earned a degree in biology from the University of Munich. Looking at his photography, it's evident that a scientifically curious mind is at work. To Peter, scientific exploration of our planet offers an almost endless possibility for subject matter about unknown places. When he hikes into an exploding volcano or chases down a level 4 tornado he is looking to return home with exciting imagery that adds to our knowledge of such places and events.

Every experience can be inspiration for the next assignment. When Peter was a university student in the early eighties, he led friends on

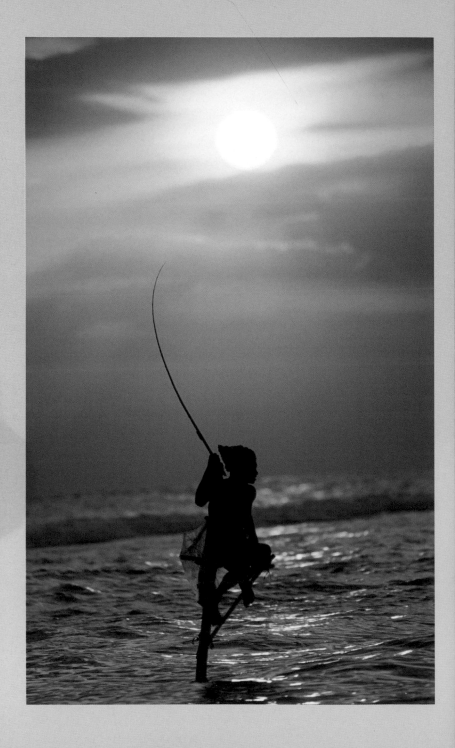

several motorcycle crossings of the Sahara. These adventures provided training and experience for his future photography and expeditions. Peter used the money he earned selling magazine stories of his Africa trips to fund his university education. Any money left over was reinvested in the next expedition to the African continent.

His early trips across Africa were done on a shoestring. "My friends and I soon discovered that the cheapest way to do these transcontinental trips was on a motorbike. Today there are many people doing these kinds of trips, so you can get information about the best bikes, routes, and sources for maps." In the early eighties Peter and his friends didn't have such luxuries as good information.

"We were poor students, so we used cheap bikes and would study the bikes in our garage to figure out the best way to carry gear on the small bikes. Our maps were bad and sometimes were copies of copies of maps. Often when out in the middle of the desert we would have the choice to fill up with petrol and run low on water or the other way around. We always chose the petrol and suffered." Twenty years later, Peter's early bike experience was invaluable preparation for his 1,500-mile camel odyssey across the Sahara.

Initially what captures Peter's interest are unknown places that have nearly impossible access. "If it was easy to reach, then everyone would be able to shoot photos and that place would not interest me," says Peter. When planning for his next photo assignment Peter looks at photography that has already been shot of the subject. If he feels that the photos are not close enough or can otherwise be improved upon, he proceeds with his research. He pays

Framed by a Sri Lankan sunset, a fisherman balances on a pole waiting for a catch. Adventure photography does not always involve danger, and often depends entirely on the patience of the photographer.

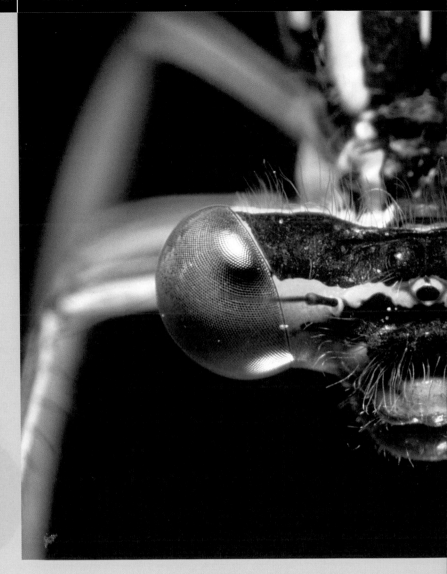

particular attention to the region's accessibility and when would be the best time to photograph the subject. His research pays off more often than not. He was on site as the Mount Etna volcano erupted, but when researching the recent activity of Mount St. Helens he determined that there would not be enough activity to improve on the spectacular photos from the 1980 eruption. So he chose not to

Carsten Peter came across this dragonfly while on location in Bavaria, Germany, and made its photographic portrait. Peter says, "Sometimes the adventure lies in the detail, and you only need some magnification to explore an entirely strange world. As a biologist, I am always searching for a special view of nature."

photograph Mount St. Helens and his research proved him right; Mount St. Helens was quiet.

To access many of his locations Peter will often pack a remarkable amount of gear so that he can be ready for anything. But it takes more than just gear to shoot one of Peter's stories. Besides photography, Peter's capabilities include rock climbing, paragliding, caving, and desert and mountain survival skills.

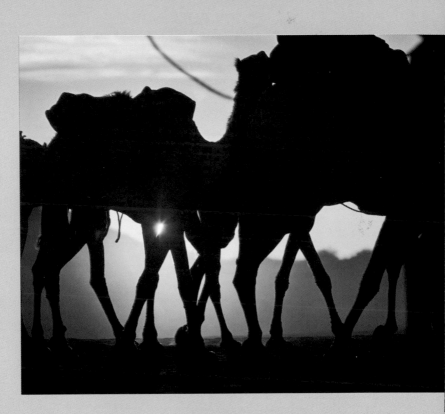

Peter photographed these camels while on an expedition in the Sahara. The trek covered 1,500 miles, tracing a centuries-old trade route. "Everything was in movement, even the sand the camels were walking on," says Peter. He wanted to get all sorts of different views of walking with camels. In this tightly focused shot, his goal was to include as many camel legs as possible.

Peter always takes great care on his shoots. In the locations that he ventures to, many people would consider bringing a doctor, driving an armored vehicle, or at least packing a big first-aid kit. What Peter packs is knowledge about his subject. When shooting volcanoes, for example, Peter knows that poisonous gases are the most insidious danger. He carefully notes wind direction and is careful to stay upwind from hot areas and places of venting gases.

This danger took an unusual twist in the South Pacific, where Peter was photographing the unique venting lakes of the Ambryn volcano in Vanuatu. He already knew the dangers of the venting sulfur and chlorine gases from the pools. But while on the tropical island he

learned that the danger multiplied when the vapors combined with the near-constant rain, creating a corrosive cocktail shower of hydro-chloric and hydro-sulfuric acid. The acid could destroy a camera and gear in little time, so to protect his gear and literally his own skin, Peter worked carefully to monitor the rainfall and the location of the worst gases around the boiling lakes.

At any given time Peter is busy planning or researching several potential photo stories. If you ask him what he is working on, he will drop hints about upcoming travels to someplace in Iceland, or caves in Borneo, but you'll have to wait until he returns from the story to learn the full picture. Peter is not being coy, nor is he trying to keep a secret. But how can a person describe a place that no one knows?

Carsten Peter Tips

- Get hooked on the topic you want to shoot. It's important to be passionate about the subject and to follow your passions when you do your photo coverage.

- Become a specialist in the subject you want to photograph.

- Once you are on the shoot, be a careful observer. With observation you learn about your subject and about the environment you are in. This knowledge will help you when you must make choices about the best locations and times to shoot.

- Don't be afraid to get up close. Use wide-angle lenses.

- Experiment with different techniques for access to your shooting location, and open your mind to a different approach to that environment. For example, you can learn to free-climb to shoot caving, or learn to use a paraglider to shoot landscapes. It pays to think of different approaches that will give you unusual or unique access into the environment you are shooting.

- Keep your gear and equipment simple. Always remember that it is not the quantity of gear that will get you the great shot. Be efficient, minimize.

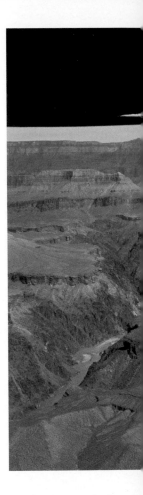

ADVENTURE PHOTOGRAPHY is probably the only field of photography that is exclusively shot by participants. Being a participant in the adventure gives you a front row seat to the action. You can use your proximity to help you focus on both the subject matter and the emotion of the events as they develop.

In a large part, adventure photography is about telling a story. I always use a story line to determine the important photo moments in a trip. I start this process at the beginning of a trip, and I become more intimately involved and tuned in to possible dramatic events as the adventure proceeds. Shooting great adventure photography requires balancing photography with participation, and combining solid camera technique with a keen observation of unfolding events. Your reward will be powerful photos that clearly illustrate the story of your adventures.

Adventure and Capturing the Story

Conceptualizing your story in advance and selecting the correct equipment are key to traveling light and getting the shots you want in the field. Knowing the subject of your story is like understanding the way the ball bounces in photographing sports; this knowledge comes with experience and understanding the game. With practice, you'll find that nine times

The background of this photo is instantly recognizable as the Grand Canyon. If you think about your subject in relation to the surroundings, your photos will communicate a bigger story to those who look at your photos later.

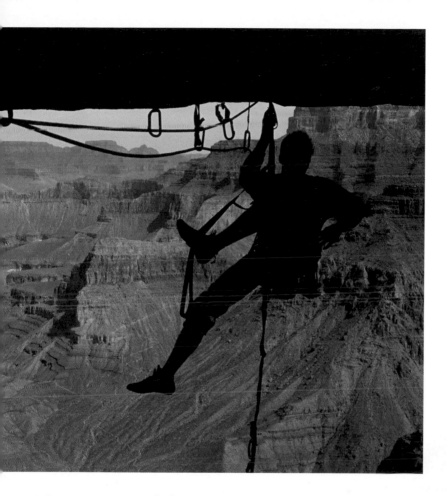

out of ten you'll read the ball right and be in the right place at the right time. But shooting a story is more than getting that one great shot. So how does one see the forest for the trees?

When I go into the field to shoot a story, I know that following the action is important, but I also keep in mind a basic journalistic tip that helps me capture the most meaningful images to illustrate the story. The basics of storytelling and the essence of journalism are contained in five basic questions: who, what, where, when, and how. Photographers as well

FOLLOWING PAGES: Shooting from across the river, I used a 400mm telephoto lens and fast shutter speed to come in tight on the action as this kayaker hit a rock in the river.

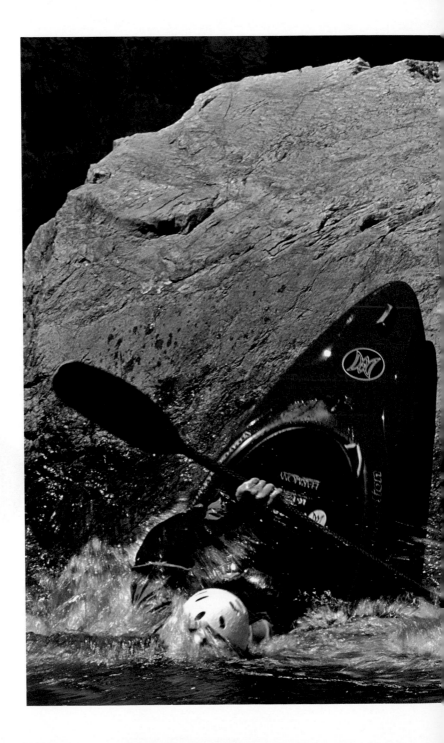

as journalists use the five "Ws" to give their photographs and stories depth and meaning and to find focus each day when working on a long assignment.

When on location, I don't simply focus on the dramatic, looking for the most beautiful light or composition for my photos. Instead,

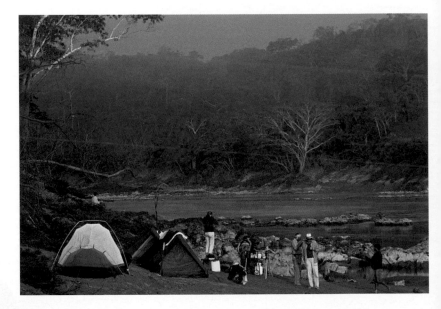

After making some shots in our river camp, I moved out of the camp for a wider shot as the sun was setting—a scenic view of our camp that included a view of the jungle canopy across the river.

I look for the essential elements of the story in each frame. I use these ideas as a guide and motivation for creating my images. The story is paramount in the images I shoot. My use of light and composition is simply the technique that translates the image most effectively into a story for the viewer. The quick way to destroy the integrity and spontaneity of a trip is to constantly arrange the subject in a shot. Instead, you should be adjusting your own position and anticipating the moment to click the shutter.

On a forest canopy expedition in Australia, I was literally trying to see the forest through

the trees. The location of the shoot was a dense eucalyptus/mountain ash forest in the Yarra Ranges National Park in South East Australia's Great Dividing Range. I was on site for several weeks to document a canopy-surveying project funded by the National Geographic Society Expeditions Council. The scientists discovered that the trees at Wallaby Creek make up a part of the world's tallest hardwood forest. Going into this shoot, my task was to photograph the scientists' work among these giant trees. Rather than just reacting to how overwhelmed I was in this stand of 300-foot giants by photographing someone standing next to a tree, I employed the five Ws to translate the story in simple photojournalistic prose. In the images, I told the story of the scientists' work among the giant trees while also capturing the uniqueness of the environment.

Real Life

My favorite image from the shoot is a photo of the scientist Roman Dial slowly spinning attached to a rope high in the forest canopy. He is entering data on a Palm Pilot, information that will be used to make a 3-D map of the forest plot. The concept I had for this shot was a POV (point of view) photo of a scientist engaged in aerial rope work in the trees. While planning this photo, I had to decide the best technique for getting the shot. I knew that to capture the blur of the forest while keeping Roman in focus, the camera would have to be fixed on his spinning rope. Attaching myself to Roman's rope would be too dangerous, not to mention counterproductive to Roman's task of collecting data.

Tip

When shooting portraits, try backing up a little to include the environment around the person.

Tip

After you have
made a wide shot,
move in closer
to capture detail
photos; these
often contain their
own stories.

My solution was to custom-build a POV
camera rig onsite. Using PVC tubing and duct
tape, I fashioned a triangle-shaped brace. At
one end of the triangle, I used a Bogen clamp
to mount a ball head and camera directed
down to the subject. Taped on the other two
corners were mechanical rope-camming

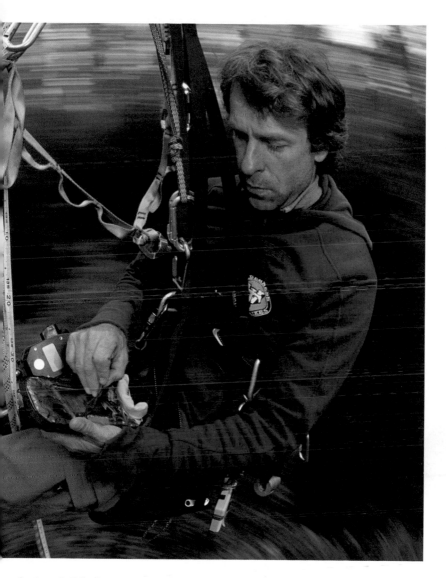

devices. With these materials, I rigged a portable camera mount that Roman could attach to his rope and move up with him as he ascended the rope to collect data.

Before the shoot, I tested this camera rig on the ground with a Polaroid back attached to the back of my SLR. With the Polaroid test

A portable flash helped achieve even illumination in this photo of scientist Roman Dial working a hundred feet above the jungle floor.

film, I was able to fine-tune lighting and composition. I determined the best lens was a 16mm fish-eye lens, since the camera-to-subject distance was only three feet. I used a compact flash with a small soft box to light the subject, and I also used the Polaroid to determine the distance and angle of the camera from the subject. I triggered the camera from the ground using a wireless remote trigger. On the particular date I used this set-up, the wind was blowing through the trees with enough force to make Roman spin faster than normal. If I had been on the rope shooting, I would have been too motion sick to shoot. The final image turned out just as I had preconceived the photo, including almost all the information essential to the story I wanted to tell.

The most important tools for rock climbers are their hands. To complete a picture story on climbers I will often photograph detail photos of their hands. Likewise, for a story about ice climbers or mountaineers I would look for possible detail photos of their ice tools and crampons. With a hang glider I may shoot details of the altimeter or high-tech helmet.

The spinning photo, however, was not in the big two-page photo spread that *National Geographic* magazine published to illustrate the scientist at work in the canopy. I had spent three days preparing and thinking through the set-up for the spinning shot to make a photo I felt would tell the whole story dramatically— yet a different photo was used.

Taken early in the morning, when mountain fog accentuated the giant trees, the chosen photo (page 84) of the scientist ascending a giant eucalyptus was much less complex to shoot. It was of an event that lasted less than a minute and took me only seconds to shoot. This photo, taken toward the end of my stay with the expedition, involved determining good composition of the trees and shooting the scientist on the rope clear of the tree foliage. Knowing when to shoot it came from my experience, after spending nearly a month among the team of tree scientists.

Why did the editors select this image for

Detail shots come in many varieties. The location of a detail shot should be instantly recognizable, whether it's a stand-alone photo or one that's accompanied by other photos from the location. This detail photo of feet with painted toes standing on coral and sand is from an ocean beach story.

publication? Because this photo captures the entire story of the canopy study, as well as being a dramatic image. When I look back at my "favorite" photo, I see that I missed the most important of the five "Ws" in getting the shot. The spinning shot fails to show effectively the unique location of the scientist in a tree that stands 30 stories above the forest floor, while the photo the editors selected does capture the dramatic landscape that the scientist is ascending into.

The canopy photo illustrates how you can place many elements into one photo. On most trips you will be shooting hundreds of photos in many varied settings. When I am shooting and making decisions on what photos I do or don't trouble myself with, I always return to the story behind my trip to find the answers.

The research and reading about the location I do before a trip is information that I can use during my shoot as background for my photo choices. Much of this research material I will write down as research photo notes that I can carry with me and refer to while on my shoot. It's surprising how often you may overlook a potentially great shot because you didn't know ahead of time that it even existed.

On a shoot in the mountains of Pakistan, I was traveling with a team of climbers from Wyoming. Before the trip they talked about how they planned to pack real coffee to brew in a real coffee pot on the mountain. Before leaving, I noted this information, along with other potentially interesting photo opportunities, in my photo notebook. Once the two-month expedition started, we were on the move every day. I was busy with many aspects of camp management, such as organizing and carrying loads to higher camps, while also planning and shooting photos of the team climbing the mountain. Because I could refer to my earlier notes, I was reminded to keep an eye on when and where I could shoot the climbers brewing coffee.

I finally had my opportunity at the climbers' camp at 18,500 feet. Without my notes I probably would have overlooked the climbers' morning ritual, which was one of several aspects of their expedition that separated them photographically from a typical expedition team. On the morning I photographed the coffee preparations and the team camaraderie over mugs of fresh-brewed coffee, I was also looking for a photo that might contrast a familiar ritual—drinking a morning cup of coffee—with the unusual location.

I've included one of the coffee session

photos here, on page 92. The photo is of climber Bobby Model with his mug of coffee. I moved in close to show his bruised and scraped hands wrapped around his coffee mug. This behind-the-scenes photo of a morning coffee ritual repeated and common throughout the world helps put a human face on the climbers. Bobby could just as well be in the local coffee shop sharing stories with friends, instead of in a camp perched on the side of a Himalayan peak. The element that makes it clear that this is no normal coffee break are the climber's hands, which are trashed from many days of hard climbing. The photo is one of several behind-the-scenes photos that illustrate the story of this team's successful mountain ascent.

The behind the-scenes photo is integral to building your photo story. Your subjects, your crew and friends, will be the players that give your story the personal touch. On a trip to an island off the coast of Belize, I had planned for the typical photos of beach fun: snorkeling, surf kayaking, fishing etc. My favorite photo from the trip, however, and the photo that carries the story of the ocean beach and island fun, is a photo of painted toes (page 81). The photo came about when our friend, an artist, offered to paint everyone's toes. The painted toes turned out so well that I decided to combine two photo elements into one. I wanted more than just a record of the pretty toes, so I moved my photo location out to the beach. The final photo combines the common beach themes of bare feet and sand, but what makes it truly one-of-a-kind are the toes painted with colorful little fish.

Before a trip, get out a pen and notebook and write down a possible story scenario and

Tip

Try POV (point of view) shots, shooting from unusual angles or from the viewpoint of the participant you are photographing. POV angles are effective in bringing the viewer into the action of the scene.

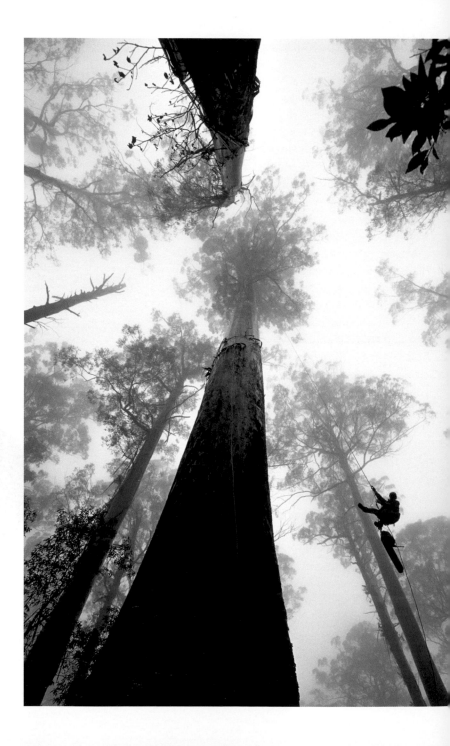

the potential photos that you might look for and be ready for. Most of these notes will be conceptual in nature. Instead of writing down the obvious photo situations, such as standing on the mountain summit or drinking hot tea, think instead of the story within the photo and feelings such as the exhaustion after the summit push, or the pleasure of the first cup of hot tea after a long cold day. This is called pre-visualizing. This is by no means a fixed agenda that you need to stick to, but rather a reference guide that you can refer to again and again on your trip. Along with the conceptual ideas, write notes you have gathered from your research. These research notes don't need to be lengthy. Often I'll use a single word or phrase as a reminder. On a trip to Borneo my research notes might read as follows: "Birds and animals are attracted to flowering plants; morning fog in river valleys; heaviest rainfall between 11 a.m and 3 p.m. (highest possibility for mud, be ready with a waterproof camera, umbrella); Islamic architecture/mosque; monitor lizard; orangutans; coastal mangrove swamps; big nasty blood-sucking leeches." These notes are simple reminders to be attentive to the unique characteristics of a region, in this instance the jungles of Borneo.

Allowing the story to guide your photography will give you focus and intent as you shoot the events unfolding in front of your camera. When I am on location shooting, I want my photos to include three things: my conceptual ideas, the places and things unique to the region, and the people and activities I am documenting. The combination of these three items, along with my own participation, will nearly always make for truly one-of-a-kind, storytelling photos.

To communicate the massiveness of these giant trees, I moved close to the base of the tree, then shot at an extreme angle to capture a dramatic view of the tree trunk fading 300 feet into the mist. The fog also helped to isolate the tree climber from the background foliage.

EXPEDITION PHOTOGRAPHY

LET'S CLARIFY WHAT AN EXPEDITION IS. An expedition is a journey with a definite purpose; it can be a trekking trip into an unexplored region of China, or a surfing trip to Baja, Mexico. The line that runs through any expedition is continuity. There is a defined start and end, with specific goals making up the core of the trip.

Professional expedition photography is perhaps one of the most frustrating types of photography. It is difficult to stay motivated and focused when shooting photos on a long trip. Trying to be in the right place at the right time to get the decisive shot on an expedition is not easy. A sports analogy I make about expedition photography is that you often feel as if you are shooting sports photos on a playing field that is a mile wide and five miles long in a game lasting five weeks. Sometimes you will feel like a rabbit running around in circles. What follows are some ideas to help you organize your photography to make the most of the photo opportunities on a once-in-a-lifetime expedition.

On expeditions lasting only a week or less, I tend to stay right with the action since time is limited and I can't afford to miss the highlights of the trip. When sports magazines send cub photographers out on their first assignments, the photo editors usually offer one piece of advice: "Follow the ball." If your expedition is

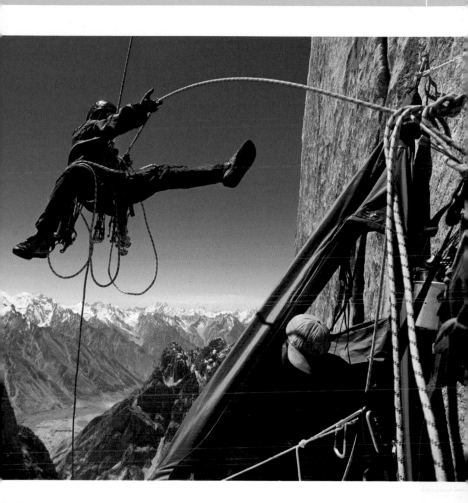

short, that's what you need to do. This is not the case, however, on longer shoots. Many people think that when you photograph an expedition it is always mandatory that you spend every waking moment with the team. For most expeditions of the traditional four- to seven-week length, this is not the typical approach.

Working with an Expedition

If you plan to spend days or weeks with the same group of people on an expedition you

A 14mm wide-angle lens is perfect for shooting from a fixed position like this portaledge camp. The wide-angle lens also gives extreme depth of field. At f/8 the lens will allow you to focus at three feet yet keep distant mountains in sharp focus.

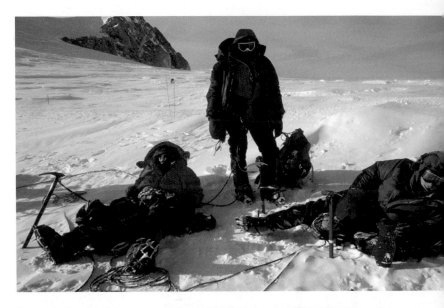

Summit day is photo-graphically the most important on any expedition, but don't stop shooting once you have left the sum-mit. This photo was taken of some of my climbing team resting below the summit of Mount McKinley. Post-summit photos of tired climbers can be telling.

will need to ensure that the integrity of the expedition is not affected negatively by your photography agenda. You must place the needs of the expedition first. Effective photography means you will need to organize your time carefully around the needs of the expedition. You and the expedition leader will need to decide how best to allocate your time. You will need to allocate time for shooting and, in the evening, cleaning and organizing camera gear for the next day. Having your pack and cam-eras ready well ahead of departure each day will keep you from delaying the team.

Because breakfast and dinner often overlap with the best light, always communicate your need to shoot morning or evenings to the expedition leader. See if you can arrange to have your meals earlier or later and what tasks you can do to compensate for missing cooking shifts or other duties. Your relationship with other team members is critical, and starting off the expedition with good communication and

These photos of the Nameless Tower in Pakistan were taken a day apart, but the action and the story in each are completely different. Changing weather and light can completely alter the mood of a photo. The top photo is of a clearing storm cloud on the Tower. In the lower photo, the single camp light brings perspective to this massive 5,000-foot granite tower.

explaining your goals and intentions will help you be accepted by team members for the long term, through good times and bad. Poor communication, making demands, and not working for the interest of the expedition as a whole will only alienate you from the people whom you will rely on for the duration of the trip. Other expedition members will be interested in your photography; include them whenever you can.

If you leave base camp or plan to be away

FOLLOWING PAGES: Often a great motivator is photographing something that you have never seen before. Unusual photos such as this shot of pedaling through slush on the Black Rapids Glaciers make for captivating images.

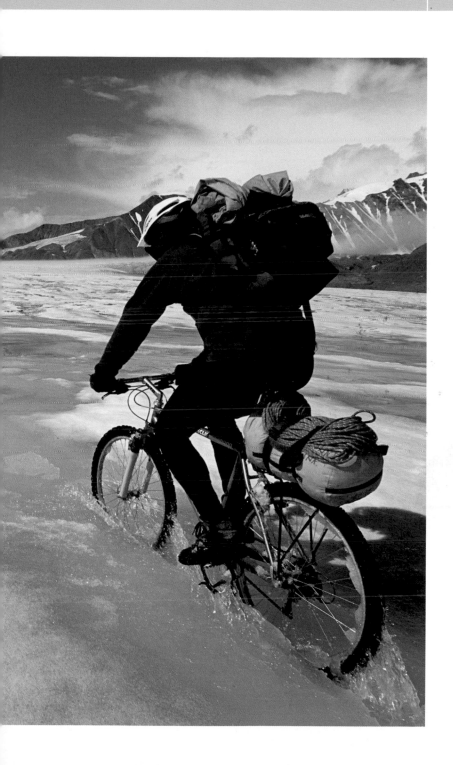

from the expedition for an hour or more, be sure to clear this with the expedition leader. When you are in the high mountains storms and other dangers could require a rescue. Let people know where you are going; if you need help it will arrive quickly.

Photo Journal

On longer expeditions I tend to forget what I shot two weeks prior, so I keep a photo journal to help me remember and stay on the road to shooting my story. The journal is my photo road map, which I constantly revise and update as the expedition progresses. I begin my shot list before the trip, and during the shoot I check off or add photos and situations that I have shot or need to shoot. My pre-trip journal, like the shot list, will outline the anticipated stages of the expedition, such as approach to base camp, establishing high camps, etc. If it is a trek, I may list towns, cultures, and other areas of interest we will be passing through. I can refer to my journal during my shoot to ensure that there is continuity to the shoot. I can also mark off situations that I feel I have documented well enough, such as static shots of base camp, the group portrait, the boats we use to travel downriver, the guides employed to move gear to camp, or the other simple shots like cooking meals.

The photo journal is also a reference; it includes the names of people and places I have photographed and other information that will be useful in captioning the photos when I return. The greatest potential disaster when shooting any expedition is that your eye is glued to the camera so much that you are blind to other activities going on that your lens

Telling a cohesive story is the key to expedition photography. The photo at right is an action shot of climber Bobby Model climbing a hand crack. The photo above shows Bobby in a quiet moment holding his mug with climbing-battered hands.

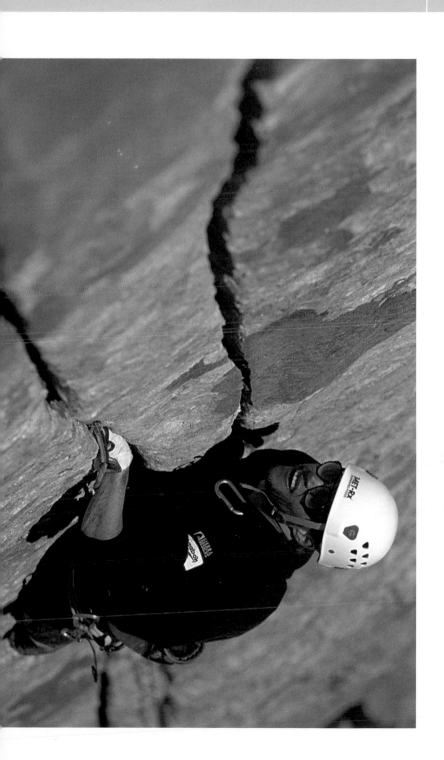

is not focused on. The most important duty of the shot journal is to help you assess the progress of your photography. Being less anxious each day about shooting literally everything that moves will help you to focus your attention on the subtle dynamics of the expedition. This, in turn, will allow you to better anticipate unfolding challenges and difficulties that beset the best adventure expeditions.

In the Field

When you are out for days and days with an expedition, your health is of primary importance. A twisted ankle or a bad sunburn can ruin your spirit to shoot. Always be conscious of where you are walking; carrying heavy loads or chasing the light or action on uneven, rough ground is a disaster waiting to happen. Understand your capabilities before racing across a glacier moraine; a twisted ankle or a fall can slow you down fast. The best way to avoid injury is to plan ahead and allow yourself plenty of time to get to your shooting location. When leaving camp to shoot sunrise or sunset photos, give yourself a 20-minute buffer so you have plenty of time to reach your shooting location.

When I'm on an expedition, I don't go to sleep until I've made sure that my cameras are packed and ready for the next day's activities. Even if I am not anticipating going anywhere, my pack is ready with a bottle of water, energy bars, hat, rain jacket, sunscreen, small headlamp, and lighter. Packing ahead is critical to avoid fumbling for lost gear in your tent in the dark and will keep you from holding up other expedition members or missing fast-breaking action.

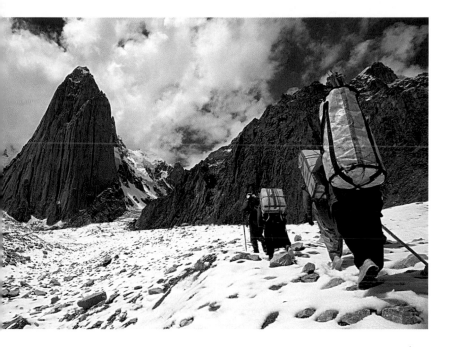

It's important to be flexibile when shoot
ing photos on an expedition. Many an oppor-
tunity has been lost because a photographer
has been too firmly fixed to the original expe-
dition agenda. If the expedition suddenly
changes course from the original goal, you
can adapt to the new situation and still get a
great story.

One of the greatest expedition stories ever
told in photos is about the aborted expedition
by British Antarctic explorer Ernest Shackleton
to explore the South Pole aboard the ship
Endurance. When their ship became locked
into icepack and eventually sank, there began
a two-year struggle by Shackleton and his 28
men to survive the harsh environment of an
arctic winter and make their way in small
boats to rescue on South Georgia Island.
The Australian photographer Frank Hurley

A low-angle view of
the porters carrying
loads to Shipton Spire
gives a dramatic view
of the tower. The
line of porters draws
the viewer's eye into
the photo to the tower.

documented the entire saga. Keeping journals and a shot list is important to help give you focus, but it should not be an anchor that holds back your creativity, flexibility, and freedom to shoot when and what you please.

Real Life: Flexibility on an Arctic Trek

The photo of a person dragging his small boat across the tundra is the one that stands out for me from hundreds of photos I took during a wild nine-day expedition across Alaska's Arctic National Wildlife Refuge from Mount Chamberlin to the delta of the Jago River. Often the photos that work do so because they are a simple personal expression of the photographer's own firsthand experience of the events. To understand what led me to make this photo means looking at the changed plans and uncertainty that preceded the moment the photo was taken.

We had intended to climb Mount Chamberlin and Mount Isto, the two highest peaks in the Brooks Range. Due to fickle weather, we were forced to change the focus

In weak arctic light, a lone figure walks in the vast landscape of Alaska's North Slope. For this shot the camera was hand held at 1/15 of a second. It was the only one of about eight shots that was not blurred and unusable.

of the expedition from a mountain trip to a hiking and river trip.

The day before we exited the wilderness we camped on the banks of the Jago River. It was here that I saw and took the photo of my teammate Roman dragging his boat. All during this Alaska adventure I was enthralled and taken with the austere landscape of ANWR. My concept toward the end of the expedition had me looking for a shot that would communicate our expedition's sense of being set adrift in the ANWR's vast wilds. The photo came to me instantly when I saw Roman drag his boat from the banks of the Jago River. The bleak backdrop of the landscape was in place; I only had to compose Roman into the scene to complete my idea for the photo. I dropped all my gear except my camera and ran ahead of Roman. In the dying arctic light Roman appeared in the camera frame as if he was the Ulysses character from Homer's *Odyssey*, lost in a vast landscape and looking for the next trial. The dragging of the boat lends a sense of incongruity to the scene, a feeling everyone on the expedition shared.

Tip

When you see a unique event unfold, don't waste time; make the best of the equipment you have in your hands, find the best position to compose the shot, and start shooting. Don't worry about wasting film or memory on your card.

DAWN KISH
Evoking Emotions

Bill Hatcher

DAWN KISH was 17, an aspiring artist and high school student in Flagstaff, Arizona. School offered her little in the way of artistic outlet. By chance, a photographer handed Kish his card and said he would be interested in having her model at his studio. Kish considered tossing the card away, but her memory of what happened when she mentioned the encounter to her mother is clear. "My mom said that this photographer, John Running, is a very, very good photographer and suggested that I stop by his studio." Kish wasn't interested in photography, but with her mother's encouragement she went to the studio.

The visit changed her life. "I stepped into John's studio and it wasn't anything like I thought it would be. It was exotic. On the studio walls were portraits and photos from all over the world. Plus, the studio was piled to the ceiling with props, lights, and cameras." Says Kish, "Those first few minutes in Running's studio was all I knew about photography and it looked cool." After her initial portrait sitting with Running, he asked if she would return so he could shoot more photos.

I spent a week with a group of professional kayakers running the Colorado River through Cataract Canyon in southern Utah. Late summer in the desert has torrential afternoon thunderstorms, and the rain created massive mud

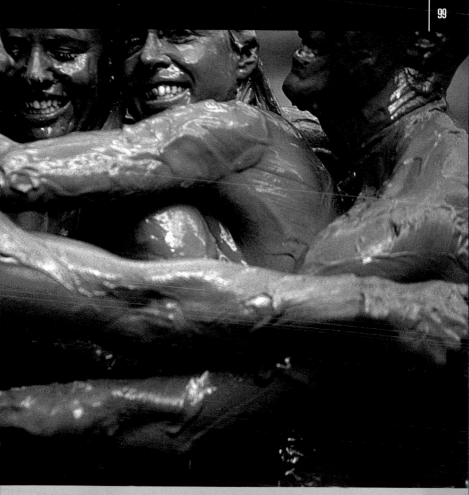

holes on the edge of the river. In the calm at the end of the day, the team needed no prompting; the mud people came out to play.

She told Running yes, on her conditions: "I was just a kid and Running was a successful photographer, but I knew if I wanted to know about photography, John would be the person to learn from. I told him if he wanted me to sit and model for him he had to teach me about photography. He accepted the offer." Their personalities meshed perfectly, and with her characteristic high energy, enthusiasm, and artistic eye, she quickly established her own internship in the Running studio, including such tasks as editing film and setting up the studio for shoots. Her first camera, a gift from advertising photographer Sue Bennett, was

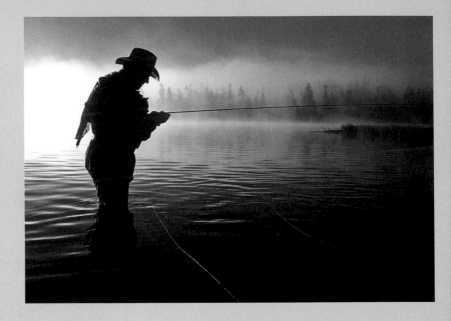

Above: Mike Lawson, the best of the best fly fishermen, fishes at Henry's Fork on the Snake River in Idaho. I backlit this shot because the fog was more mysterious from this viewpoint.

Right: I took this picture of Tamra Hastie climbing at Le Petit Verdon, outside Flagstaff, Arizona. I remember seeing the beautiful natural light and having her sit in the right spot as she coiled her rope.

given to her just before she turned 18. She still uses this Nikkromat camera today.

Kish finished high school, then packed her bags and hit the road. For two years she traveled in the United States, Europe, and Africa. When she was 20 she landed in New York City, where she supported herself by modeling and immersed herself in painting, photography, and the New York art community. A year and a half later she switched coasts, moving to San Francisco. On the West Coast she reconnected with her outdoor friends, quit modeling, and began supporting herself with graphic-art jobs and shooting stories for snowboarding magazines. By her mid-twenties she began working as a guide on whitewater rivers and shooting outdoor photography full time.

For Kish, danger is part of capturing many of her images. She has had her share of close calls, from a near-drowning in her kayak, when she was pinned on a rock on the Salmon

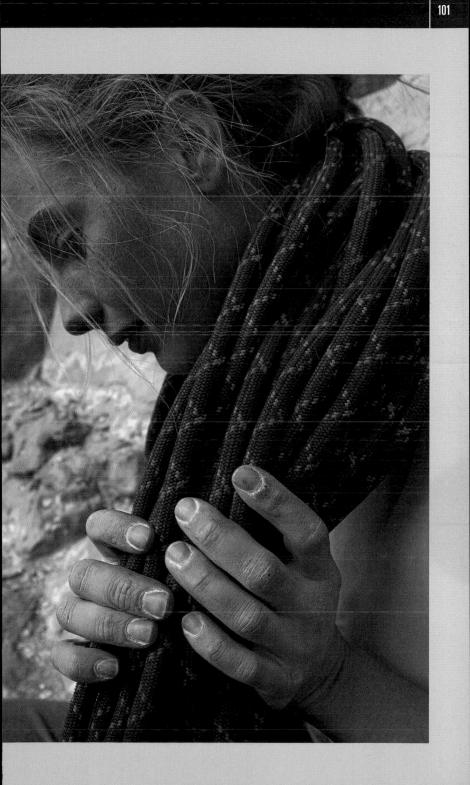

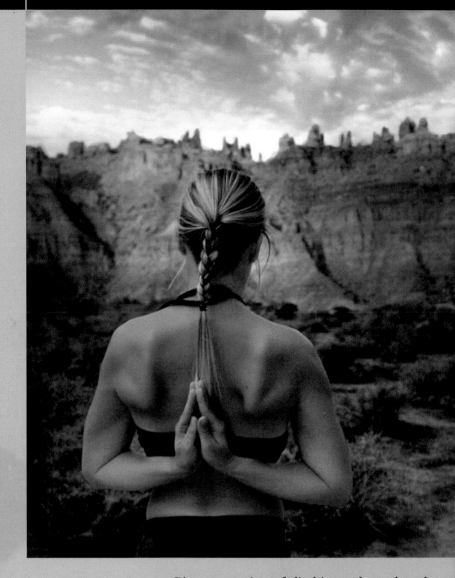

River, to a variety of climbing and snowboarding injuries. But as her photography attests, she travels in the outdoors to relax, not to take chances. Says Kish, "I've always made positive choices in the backcountry. If I feel I am walking into a dangerous place, I'll turn back if it looks unsafe." To be more prepared for the dangers, Kish has taken advanced avalanche classes and is certified in river rescue,

Alexa Trujillo was drawn to this beautiful place called the Dollhouse in Canyonlands for her morning practice. Because it was so dark in the canyon at 6 a.m., I used a flash reflected off a white board to give a soft light on her. Then I used a neutral density filter on the sky.

Wilderness First Responder, and CPR. Asked what scares her, Kish replies, "I am more scared driving down the highway where you have a total stranger speeding past you at 60 mph than I ever would be in the outdoors."

If you ask what she looks for when shooting photos Kish replies, "feeling: I want the photo to show what it feels like to run in the rain, roll in the mud, or climb a rock. I try to avoid

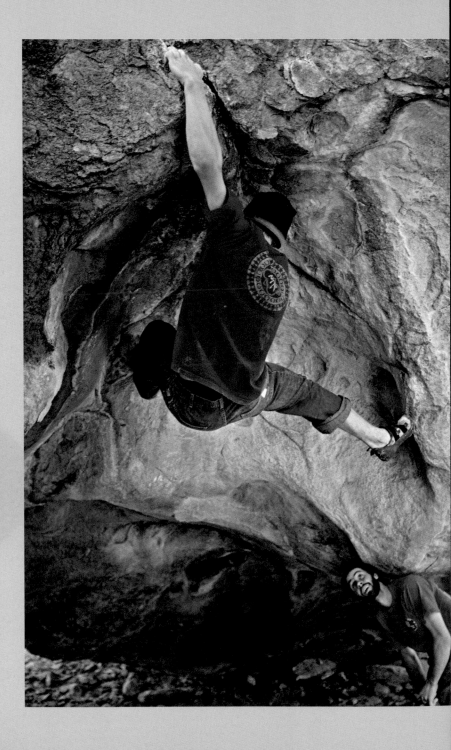

posing people because I find it makes them look too static. I let the people and their actions control my photos, not the other way around. It's the fly-on-the-wall approach. I shoot as events and action unfold around me."

Dawn's clients include *Sports Illustrated, National Geographic Adventure, MTV, Outside, Trans World Snowboarding,* and *Arizona Highways,* to name a few. Her award-winning photography has been honored in *Graphis, Communication Arts, Photo District News,* and the *American Institute of Graphic Artists.*

Dawn has no formal education in photography, but her early mentoring by John Running gave her a love for different cultures, people, and lifestyles. Kish and Running still get together to help and assist each other on photo shoots, and after a 16-year friendship they both are still learning from each other.

The biggest challenge when shooting bouldering is getting a good angle. I climbed a nearby boulder so as to shoot down on local climbers at Hueco Tanks Historical Park in Texas.

Dawn Kish Tips

- Have fun!
- Pay attention to your subjects; they are vessels of emotions and will make or break a photo.
- Go with your instincts. The photos you are shooting are your own personal expression of what you are seeing and feeling at that moment.
- Observe the light. Even when you're not shooting, be thinking how you might use light to shoot a photo.

- Try not to force your photo. Allow the events to unfold naturally. Don't feel that because things aren't going the way you envisioned them that things aren't working. Be open to serendipity and surprise.
- Stay clear with your vision. Your most original ideas come about when you follow your own creative vision.

- Keep a journal, and don't forget to go back and reread it. It can help you when you assemble your photos into a story.
- Use any camera you want. A photo opportunity happens no matter what equipment you have on hand. Don't feel that because you don't have the fastest camera or the biggest telephoto that your photography is compromised. Shoot now!

Inside the Game:
A Primer on Shooting Adventure Sports

WHEN OUT ADVENTURING you will come across many situations that will require special planning for the equipment you carry and the strategy for shooting. A simple camera package will work for most of the sports and other situations I will discuss below. For many of these outdoor photo pursuits, first determine environmental hazards to yourself and your equipment. Safety, for both you and the people you are photographing, is your highest priority. No photo is worth putting yourself or others in harm's way. This chapter outlines the basic tasks for planning and executing a shoot on rock, water, snow, or sand.

Hiking, Biking, Backpacking, and General Exploration

Trip weight and bulk should be your chief concern when packing your camera for hiking or biking. When you are deciding what camera equipment to bring, try to anticipate the photo situations that are most important to capture when on the trail. I typically carry a camera with one or two lenses; a 24-85 zoom with a macro feature is my favorite. A second lens to consider is a telephoto, such as a 70-300 zoom,

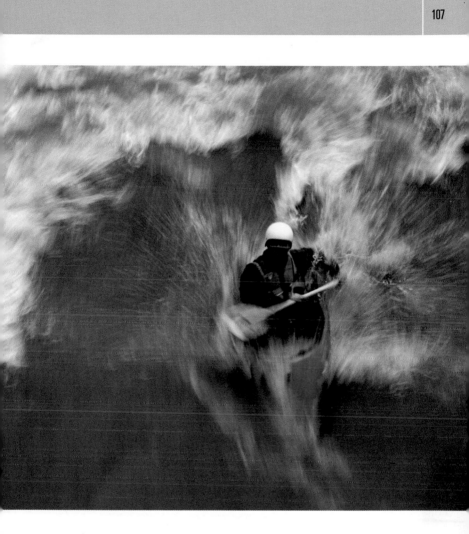

or a 28-300 lens. The telephoto is an excellent lens for action photos and for compressing a figure in the landscape. The variable aperture on the telephoto zoom keeps the lens compact and light. Some lenses have an image stabilizer function that will enable you to handhold the lens at much slower shutter speeds.

I always like to keep my camera handy when I am out hiking, backpacking, or biking. For biking, keeping the camera in the top of your hydration pack will give you adequate access. Of course, when you are biking, your

A fast-breaking sport requires a fast motor drive and a willingness to shoot a lot of frames. With the water sweeping beneath the boat at 20 mph every tenth of a second, the kayaker, the paddle, and the water have moved in a thousand ways.

Tip

Always be on the
lookout for humor.
You might be
surprised at how
frequently it shows
up, even in the
most extreme
environments.

camera lens combination should be as light
as possible. A camera with a compact 28-200
zoom lens with a variable aperture is an ideal
biking lens. The zoom range will enable you
to isolate a rider on a trail from some distance.
Some bike riders may consider using a camera
chest harness. This setup allows much faster
access to your camera, but I prefer not to use
it since the camera is quite bulky. To always be

ready for the shot, you might consider a compact point-and-shoot camera, which you can keep in a pocket attached to the shoulder strap of your bicycling hydration pack. Keep your camera in your pack or bike pannier when you are riding your bike.

On hiking trips I carry a camera either around my neck or in a small fanny pack. I keep my camera handy if I am traveling

This point of view (POV) photo brings the viewer into the driver's seat. A camera with a 16mm lens was attached to the bike; I triggered it with a wireless trigger from the side of the trail.

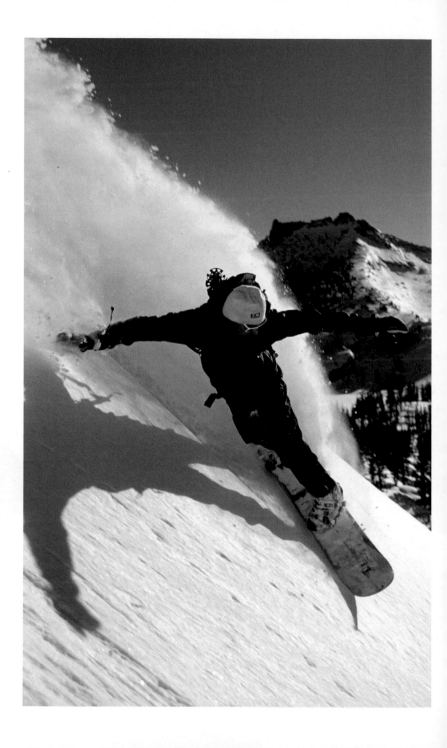

through villages or other interesting or unique terrain. I also always have my camera out and ready to use during the good light of early morning or late evening, if it is foggy, or if there is other interesting light. When the sun is higher in the sky, generally between 10 a.m. and 3 p.m. in all but extreme north and south latitudes, I typically keep my SLR camera in my pack. The sunlight in the middle of the day is harsh, contrasty, and generally leads to poor photos.

Before going out, remember to custom tailor your camera gear for each particular trip. Try to anticipate the situations through which you'll be traveling. You can choose specialized lenses if, for example, you know you will be hiking in narrow slot canyons where you might want a wider lens. If you will be around wildlife, you might lean more toward a telephoto lens. In some cases you might decide to bring a lightweight tripod for low-light photography, but to save weight you can consider a beanbag instead of a tripod to brace or cradle your long lens for scenic photos or night shots. Of course, on a hiking, backpacking, or biking trip you will be carrying all of your camera gear.

If you are shooting in the desert, you will have to take special care to keep windblown sand out of your cameras. Packing lenses and cameras individually in sealed nylon Ziploc bags is a good line of defense. Avoid changing lenses or opening the back of the camera when the wind is blowing hard enough to blow sand around. Heat is another hazard in the desert. Film is sensitive to heat; keep it stored in a cool place. I have kept film rolled up in my sleeping bag, where the insulation of the bag keeps the worst of the heat from the film.

When shooting a high-speed sport like snowboarding, I rehearse the boarder's trajectory through my camera lens. For the real shoot, I have already practiced the camera movement, so when the boarder blasts past, it's just a matter of following him in the frame. When he's within shooting distance, I hit the shutter and continue to follow him with my camera.

A brush and compressed air can clean most sand and dust out of a camera or off a lens. If you discover your lenses are grinding in sand, send them to a camera repair facility to be cleaned. If not removed, the sand can continue to damage the lens and camera.

On any self-supported outing, the most important consideration when packing is to keep your camera weight and bulk to a minimum. You will have to make sacrifices to do this. Make your choices carefully. Traveling as light as possible will give you the energy and freedom of movement to enjoy shooting photography on your multi-day outing.

Snow Sports: Skiing, Snowboarding, and Winter Camping

Typically, when shooting skiing and snowboarding, you will be ahead of the skier or boarder looking for a likely shooting location. Speed is of the essence in ski photography. Keeping your camera in a pack makes access too slow. Instead, use a hip pack that has a waist belt and shoulder strap. The hip pack should have a zipper to keep out snow. Some manufacturers make hip camera packs that integrate with a daypack, which is an even more stable way to carry your camera when skiing. The pack can be used to keep food, water, and extra lenses. You should not wear the camera dangling from your neck by its strap or under your jacket when skiing or snowboarding; if you fell, the camera could injure you.

Because of the fast action of snow sports, consider using a camera with a high-speed motor drive; six to eight frames per second is standard for a sports camera. But you can still

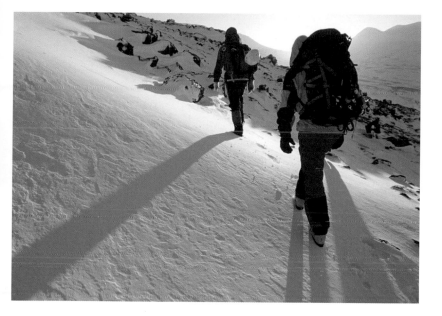

take great photos with a slower motor drive. The ideal lens for ski or snowboarding photography is the 70-200 lens or the 70-300 lens.

Once you have found the location from which you will shoot the oncoming skier or boarder, you will need to determine the light metering. If you are metering the scene with the camera's in-camera meter, you will want to overexpose the snow by +1 3/4 to +2 1/3 stops to get the correct exposure on the subject. The sun reflecting off of the snow will help to fill shadows on front-lighted photos. Backlighted photos on snow are very dramatic and will require careful metering. Determining the correct exposure is a learning process. If you want to bring out more detail in the snow, overexpose the snow by only one stop. The most accurate ways to manually meter a subject on snow are with a handheld meter, by spot metering the subject, or by using an 18 percent gray card, which can be purchased at photo stores.

The snow is a main component of this shot of ice climbers hiking to cliffs in Iceland. I metered for the light on the snow so as to bring out the patterns and shadows on the snow.

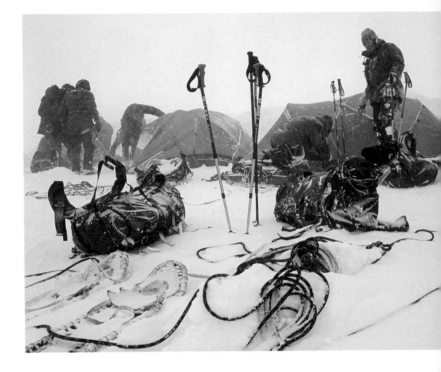

Some cameras have a fast enough auto focus to photograph a skier or snowboarder coming toward you. If your camera does not focus quickly enough, you can mark the photo spot with a tree branch or other unobtrusive object. You can then prefocus on the spot and instruct your subject to turn or perform other tricks just ahead of the marker spot. By the time they reach your marker they are at the height of action. Be careful to compose your frame carefully so you don't cut a head or arm out of your photo frame.

Battery power is the major equipment concern when shooting in cold weather. Alkaline batteries lose much of their power and eventually do not work in temperatures below freezing. Use only lithium batteries if you know you will be shooting in freezing

temperatures. Lithium batteries work in temperatures as low as −40°F. In the coldest temperatures the lithium batteries may only have enough power to shoot a few rolls of film. This happened to me when I was shooting photos on summit day on McKinley. I found that at −40° the performance of my lithium AA batteries was greatly reduced. Carry many spares if you plan to travel in extreme cold. Rechargeable batteries perform well in the cold. Most digital cameras are using lithium-ion batteries, which have excellent performance in the cold.

From a low-angle perspective, I focused on the frozen ropes in this storm shot on Mount McKinley.

Another precaution you should be aware of when shooting in the cold is to wear gloves— even liner-weight gloves. Touching the metal body of a camera when temperatures are very low can cause contact frostbite. If you are shooting in falling snow, be sure to keep the lens clean of snow. You can do this by tapping the camera to knock flakes off the lens or by using a lens brush. Never touch the camera optics with your glove.

If you are riding a ski lift, take precautions to avoid tangling your camera bag or pack straps in the lift chair.

The greatest environmental hazard to camera operation in the cold is condensation. Moisture from condensation will settle on cold external and internal camera surfaces when the camera comes in contact with warm air; this occurs when a camera is moved from cold temperatures (below freezing) into a warm room, tent, or jacket. The moisture associated with condensation will play havoc with the sensitive internal electronics of a camera, as well as cause fog on the camera and lens surfaces that will refreeze when taken back out into the cold.

If you do bring a camera into a warm area

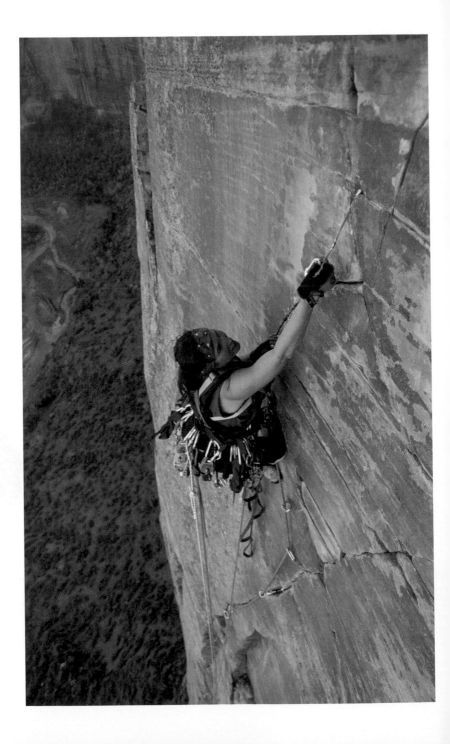

from the cold, keep it in a camera bag and allow an hour or two for the camera to slowly warm to room temperature. Wearing the camera under your jacket can fog your lens because exercise, even in extreme cold, is sweaty business. When using your camera outside on very cold days, be careful not to breathe on the camera or lens as this will cause the condensation from your breath to freeze instantly on the metal body and glass lens.

I shot this with a wide-angle lens from a fixed rope above the climber. The leading line from the climber's raised arm helps to accentuate the sweep of the wall in Zion, Utah.

When I am on a winter camping trip and I enter my tent on a cold day, I take the batteries out of my camera and leave the camera in its zippered camera bag in the tent vestibule. If it is a snowy or windy night, I seal the camera in a Ziploc bag to keep out the snow. Keeping the camera outside the main compartment of the tent keeps the camera acclimated for shooting outside. If you want to shoot photos inside the tent, depending on how cold it is outside, it may take an hour or more to warm the camera for the inside temperature. With the camera outside, I keep the batteries warm in my sleeping bag.

Remember that shooting fast action sports requires shooting many frames, of which only a few photos will be in sharp focus or composed in the frame. Be ready to shoot many, many photos. Stay warm.

Rock Climbing

Photographing rock climbing or ice climbing presents some basic challenges that need to be considered before you tie in or clip an ascender to a rope.

As you have probably noticed, most of the climbing photos that grace the magazine pages are not typical photos from the belay ledge,

but are photos that are planned and staged for the photographer. There are three basic ways to shoot climbers. The method I always consider first, because it allows the most freedom and therefore the most creativity, is shooting from the ground or from other positions that can be reached non-technically. Some of climbing's most creative photos are taken in this manner. A zoom lens up to 40mm can be useful for this shooting tactic.

The second method frequently used to shoot climbing, and the most popular method used in the climbing magazines, is to rig a rope above your climbing subjects. This method requires setup ahead of time, and for this reason is normally staged just for the photo. The staging could include climbing the route ahead of the climbing subjects or lowering a rope from the top of the cliff. Setting the rope anchor and the rigging for this type of climbing shoot is technical and requires extensive climbing experience. Typically when shooting from a fixed rope, you shoot from a position above and 30 degrees to the left or right of the climber. The position from the rope is dramatic, and therefore very popular.

Creatively, there are drawbacks to shooting from a fixed rope. Because you are attached to a rope your options for angles are few, hence the generic look of this type of photo. The best lens choice for this style of photography is a wide-angle zoom lens, usually a lens in the 17-35mm zoom range. If you are setting up a rope from above and want something more than the generic view, consider tighter compositions with a zoom lens, and look for any unique characteristics of the rock or the climb that you can incorporate in the composition. Use of a telephoto lens shooting directly down

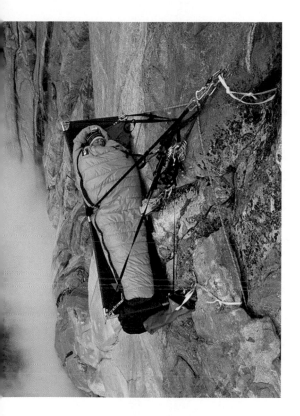

A clearing storm can offer a range of exciting photo opportunities, such as this shot looking down on a climber sleeping on a portaledge fixed to the wall of Yosemite's El Capitan.

an off-width or looking to include the natural surroundings in the photo can give a creative stamp to your fixed-rope climbing photos.

The third, and I might add the most difficult in terms of getting a good photo, is shooting as a participant, and photographing your own and your partner's ascent. When you are participating in the climb, you are often in a poor position to shoot since you are either belaying or leading at all times. But don't despair; with a creative eye and some planning, you can capture great shots. The strategy that I find works the best when I am a tied into a rope with my climbing partner, and which avoids the classic butt photo angle, is to first study the climbing route carefully. With just a little pre-planning

FOLLOWING PAGES: The wall to the left and the foreground shadows create a spectacular picture-window view of distant mountains.

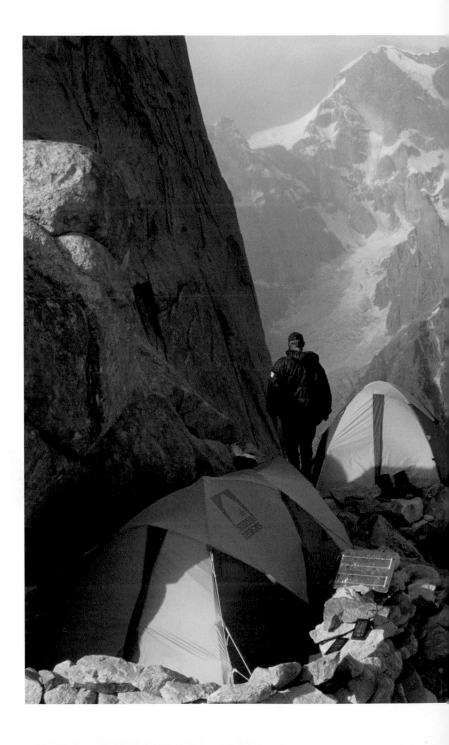

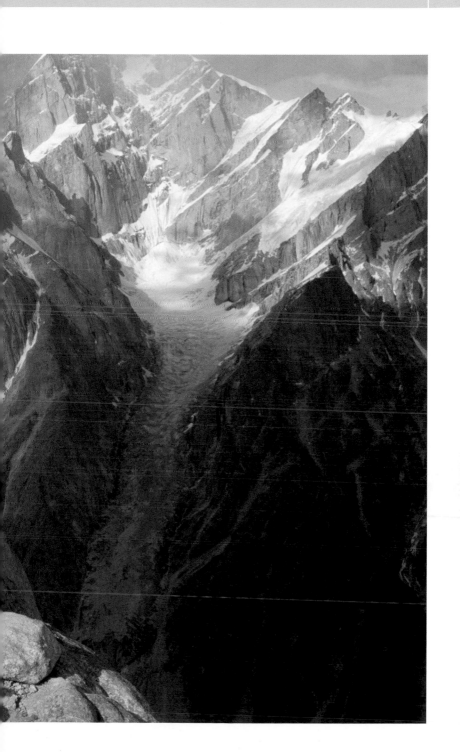

you can arrange to be in the best position for photos, pitch after pitch. This way, you can work quickly, without interrupting the rhythm of the climb again and again for a photo.

On any climb I try to capture the essence of the ascent. I ask what is the location, what is the type of rock, is there a pre-dawn start, etc. In my quick assessment of the climb I am trying to figure out where the cool shots might happen. When I look at the pitch-by-pitch description of the climb I look for places where I can get the best vantage, such as places on traverses or at any part of the climb where the leader is climbing diagonally off the belay ledge.

Climbing is often a midday activity, and the light is harsh. Look for the possibility of silhouettes on the cliff skyline and dramatic shadows. Look at how the sun shines on the route. It's best to have as much frontal light on your subject as possible, as midday light will create bad shadows. An on-camera flash is handy when the subject is closer than ten feet. Some point-and-shoot cameras have an auto-fill flash command; try using that feature. By looking at the angle of the sun you can decide if it's better to lead the pitch and shoot your partner climbing toward you, or if the light will be better shooting your partner leading off the belay. If you are belaying, you can use a camming belay device such as a Grigri to safely shoot and belay at the same time.

A camera with an auto-focus lens is extremely valuable. I often carry a small point-and-shoot camera, one small enough to fit in a pocket, instead of a large bulky SLR. Get a P&S with as wide angle a lens as you can. Some digital and film point-and-shoot cameras allow you to fit a wide-angle lens adapter over the

camera's standard lens. When you are shooting the climber from the belay once the climber is more than 20 feet from the belay, you usually lose any effective shooting angle. In other words, the climber is now directly above, and it's back to the classic butt angle again.

Most important of all, be ready for unexpected opportunity. A lucky photo break was given to me during a first ascent of 'Tricks of the Trade," a 1,200-foot climb in Zion, Utah. In the three days it took us to complete the first ascent I was looking for the one great shot that would characterize the amazing experience of making this first ascent.

On day two on the wall, my two partners, John and Brad, and I had climbed up 800 feet of the wall. We were climbing fast to reach the summit before dark. On the climb's dramatic headwall, I wanted to fix the ropes for a shot, but with the time crunch and 300 feet of unknown difficult climbing above us it would have been intrusive and even dangerous to ask the climbers to delay the ascent for a photo. I was belaying John, who was just finishing his lead on the second pitch of the headwall. Brad was below us cleaning the previous pitch. At that moment, Brad dropped our only wall hammer. He let out a yell and all three of us watched as the hammer fell 150 feet to the ledge we had slept on the previous night. The hammer didn't fall any farther. It was our only hammer; Brad knew what he had to do, so he set ropes and began the rappel down to the ledge.

At that moment the photographer in me jumped into action. I had John quickly belay me to the top of the pitch he had just led. Then I told him my plan. John rappelled back to the lower belay. When Brad joined him at the ledge after retrieving the hammer, John

Tip

Carry a couple of one-gallon Ziploc bags. They are waterproof and dustproof and can be used to protect lenses and film. A bag can also be fashioned into a tent cover for your camera so you can shoot in the rain.

then re-led the pitch with me shooting him from above. We had lost little time in our dash to the summit. We finished the last pitch at sunset and slept on the summit of Isaac under a clear desert sky.

Boating and Water Sports

Looking out to the ocean from the same viewpoint as the kayaker helps make the viewer a participant in this scene.

Camera protection is critical in shooting water sports. Fresh water is corrosive and salt water even more so; therefore in surfing, rafting, and most paddle sports a waterproof case or bag is a must. A discussion about camera protection on water is included in the chapter about gear.

On a rafting or paddle trip, expect to be on the water about four or five hours a day. If you have a waterproof case for your camera and you are careful, you can take photos while sitting on the boat in flat water. You can ask the raft guide or other knowledgeable person on the boat if the upcoming rapids will be splashy or if you should expect a complete dousing.

If all you are protecting your cameras from is a few drops of water, a plastic bag with a hole cut out for your lens should suffice. If you need total splash protection for your camera, consider getting a flexible glove housing like the Ewa Marine. It takes time to load your camera in this housing, so consider having two cameras on the boat, one in a housing and one out of a housing. This will give you the flexibility to change lenses and make other camera adjustments. An inexpensive setup is to use a compact point-and-shoot camera in a waterproof housing for on-the-boat shots, while keeping your SLR in a waterproof hard case.

The best lens to use for shooting in a boat is a wide-angle zoom lens, such as the 17-35 zoom. Your position in the boat is essentially

fixed, so using a zoom lens is very important. Be sure to hold on and brace your feet on the side of the boat when you drop into a rapid. Boat motion in rapids can be very violent and not unlike riding on a bucking rodeo horse. If your cameras do get wet you can dry them with a towel or a chamois cloth and set them

in the sun to dry for a few minutes.

Many boating, kayaking and surfing photos are taken from shore. How far you are from your subject will decide what telephoto you will need. For most rafting and boating shots a 70-200 image stabilizer lens is perfect. If you are shooting surfing or other surf sports from shore, you will want to consider a 600 or 800mm lens and possibly a 2x telephoto extender to give you even more reach. A fast motor drive on your camera is a bonus to catch the action. To shoot boats going through rapids, position yourself on shore in a place that has a clear view of the action. The best

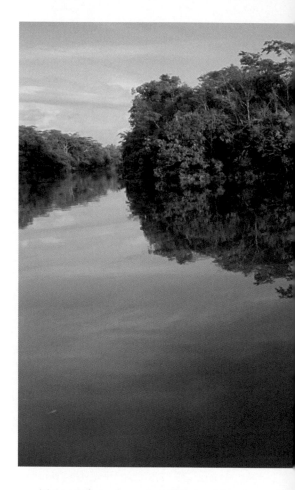

The calm air of early morning gives the water a mirror finish near this Amazon village. I used a two-stop neutral density filter to bring the exposure of the sky down to match the exposure of the reflected water.

position onshore is even with a rapid or slightly downriver and just above the water. Be aware of background elements that can distract and clutter your photo.

Boats on moving water can beautiful. Play with adjusting your camera to slower shutter speeds to see what you like best. The chapter on composition discusses shutter speed and action blur. Another creative tool when shooting water is reflection. Look carefully for water reflections on calm water during sunset and sunrise. Reflections become most prominent

when the water is between you and the brightest part of the sky.

If you are shooting around salt water remember that salt water is far more corrosive than fresh water, so you should dry and clean your camera carefully each day. Ocean surf causes saltwater spray to be suspended in the air. When around surf keep your camera covered and protected from the saltwater spray.

With care you can shoot every aspect of a river trip, a surfing trip, or a day at the beach with the kids.

JIMMY CHIN
Shooting from the Edge

Brady Robinson

GROWING UP in the flat-lands of southern Minnesota is not a particularly auspicious start for a world-class mountaineer and adventure photographer. "I was 12 when I had my first epiphany about the mountains. I went on a family vacation to Glacier National Park. The beauty of the West and the mountains of Glacier National Park really blew my mind. I was changed forever. I always knew I would return, and I did. I spent two summers working in Glacier when I was 18 and 19, running up as many peaks as possible. I had also started rock climbing in Joshua Tree. Spending time in the mountains and rock climbing became my passions." Photography came later and could be described as a fortunate accident. During a climbing trip to Yosemite, where he was training for an upcoming expedition to Pakistan, Chin took a photo with a friend's camera during their climb of El Capitan. His friend submitted some photos of the climb to an outdoor clothing company and the photo editor bought one image: the photo Chin had taken. Encouraged by the sale of his first photo, Chin bought his own camera and hasn't

During an attempt to climb a new route on the southwest face of K7, we were battered by a five-day storm high on the mountain. Conrad Anker, Brady Robinson, and I were confined to our undersize two-person portaledge several thousand feet up the face. Due to wind and

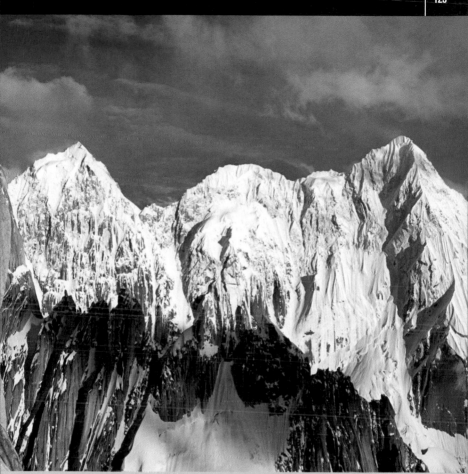

snow, our visibility had been nearly zero when we put up the portaledge. When the storm finally broke and we could see our position, I crawled out of the portaledge and traversed out on a small snowfield to snap this photo.

looked back. His dramatic photography of human endeavors in extreme mountain environments has been published in magazines such as *National Geographic, Adventure, Outside, Men's Journal, ESPN Magazine, The North Face,* and *Patagonia.* His photography has won many accolades and awards, and in just a few years he has become recognized as one of the best extreme mountain photographers in the profession.

Besides wild mountain locations, what distinguishes Chin's photography is his strong sense of composition. It is a rare gift to be able to pick up a camera for the first time and

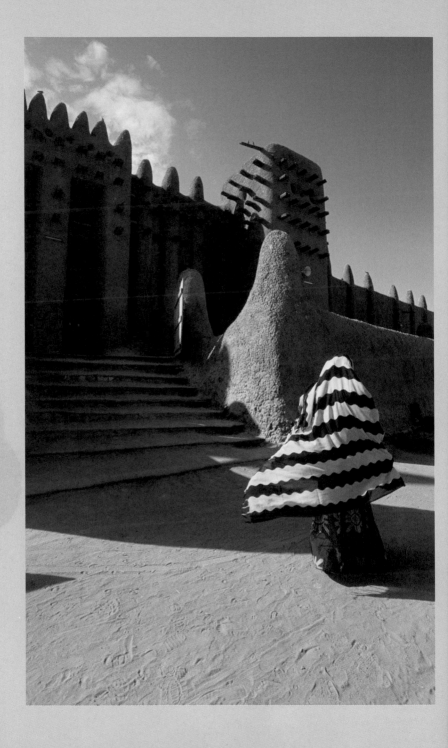

shoot a publishable photo. But Chin was not new to composing within a frame. Chin's Chinese-American parents wanted to instill the family's culture in their son. They spoke Chinese at home, and taught Chin, from age five until he was a teenager, to draw Chinese characters and calligraphy using a brush and ink. As Chin remembers: "I developed a talent for drawing the characters. I enjoyed drawing, but I loved the discipline of drawing characters. They demanded attention to detail, and an eye for balancing the different symbols inside the frame. The symbol for water, for example, has to be done perfectly or it will appear out of balance." Chin attributes his ease with photo composition to his many years of studying and drawing Chinese characters. "When I started shooting photos I didn't really think too much about composition, it came naturally."

Something else that came to Chin naturally is his exceptional climbing and skiing ability. His ease on rocks and snow in the high mountains has allowed him to become the ultimate practitioner of what the late photographer Galen Rowell termed, "participatory photography." Chin is able to carry a camera where few dare to go, as well as return with artfully crafted images. He paces himself carefully on expeditions, balancing his role as a team member with the demands of shooting assignment photos. Chin feels that one of the most important parts of his job on any expedition is to first be a solid, reliable team member and climber; the photography comes second. "The success of the expedition and safety are the priorities. As a climber, you face a lot of challenges on these expeditions. As a photographer, one of the great challenges is trying to be creative under fairly stressful situations. You try to be smart

In December 2003, I journeyed to Mali with a team of climbers to search out and climb on the towers of the Hand of Fatima—a formation on the southern border of the Sahara that contains the tallest freestanding sandstone towers in the world. We stopped to resupply our food and water in Djenne. To avoid the midday heat, I headed out to the market early in the morning, where I caught this woman hurrying past the Djenne Mosque.

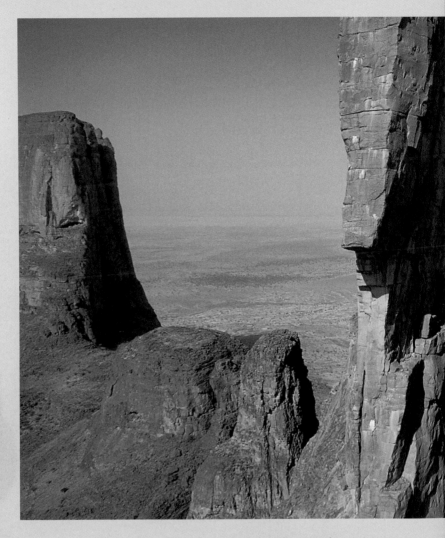

about what you are shooting by anticipating the key moments and being efficient with your creative energy as well as your physical energy."

Chin participates in and shoots about three or four major expeditions a year. "No two expeditions are the same, so you can't preconceive how an expedition will unfold. Often, I will make a shot list before a trip and continually revise and add to it during the trip. These

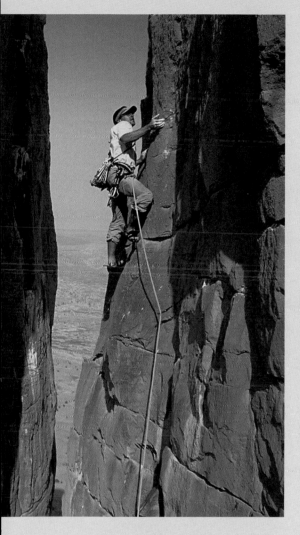

While climbing the towers of the Hand of Fatima in Mali, Evan Howe and I put up a new route, "African Reality," on one of the towers to get into position to photograph climbers on some of the other towers and also to try to capture the uniqueness of this geologic phenomenon. I got several of the shots I wanted from this position, but later found that the spontaneous shots of Cedar Wright climbing our new route were some of the best surprises in the batch.

lists help remind me of potential conceptual photos that might capture such ideas as teamwork, overcoming challenges, discovery, adventure, and success. Photographing an expedition is like building a film; it's storytelling. I always look for transitional moments, such as arriving at base camp, establishing climbing camps, the big storm, and summit day." Chin employs many strategies, but

In the spring of 2002, I was invited to join Galen Rowell, Rick Ridgway, and Conrad Anker on their unsupported traverse of the Chang Tang Plateau—the highest desert plateau in the world. Our goal was to follow the migration of the elusive and endangered Tibetan antelope, or chiru. This image of my three mentors is a very personal picture and a memorable moment.

making the best of where he positions himself is key. "I try to be efficient in my shooting. If I run ahead of the group to shoot, I'll photograph them walking toward me, then I'll drop to the ground and shoot wide to get close-ups, cutaways, or an interesting angle of the boots and crampons as they walk past me, and then I'll recompose for another shot as they walk away into the landscape. From one position I have shot three unique compositions."

Chin's favorite photo moment was at the end of an expedition to discover the birthing grounds of the endangered chiru antelope on China's Chang Tang Plateau. Among the expedition members was Chin's mentor Galen Rowell. When climbing a nearby mountain. Chin's team had to chop a hole through a snow cornice just below the summit. "I had just

poked my head through the hole." says Chin. "I looked down the ridge and saw Galen climbing toward me. My feet were dangling in space but I had my arms, ice axe, and camera free. I could have climbed out of the hole for a more secure footing, but I knew the moment would be lost, so hanging on by one arm I squeezed off three shots. One of them ended up as a two-page spread in *National Geographic*."

Jimmy Chin Tips

- Write down a shot list before a trip and take time every night to add to and revise it. This is a great way to make sure you cover your bases and help you visualize and anticipate key shots. Once I've covered my bases and am "warmed up," I'll begin to take more risks photographically.

- Plan on getting to locations early, especially if you are waiting for good light. I do a shoot before the shoot, so when the good light hits, I have a solid idea of what I want, what is working, and what I don't need to waste time on.

- For expedition shooting, staying ahead of the team is key. Have your gear clean, organized, and ready for the next day so you can help with camp chores and still be in front of the team as they head out of camp.

- Critical gear includes a Sharpie felt-tip pen, for marking special instructions on your rolls of film; Ziploc bags to save your film from water-related accidents and for organizing film; and a chamois for wiping water off cameras and fogged lenses.

- Keep a fairly detailed journal of what happens during the day, names of people you shot, etc.

- If you are not sure of your exposures for certain light, mark the roll as a "clip." Shoot the first few frames of the scene as test shots. Back home the lab will clip your film and process only the first few frames to determine the proper processing time. The lab will then process the rest of the roll for the correct exposure. If you are shooting several rolls in the same light, drop them in a Ziploc bag with the "clip" roll. This way, you can clip test one roll and have a good idea of the exposure on the rest.

- I always "clear" my camera in the evening when I am cleaning it. This means setting the ISO to the DX setting, making sure my exposure compensation is zeroed, setting my metering to a matrix setting, and zeroing the flash compensation on the camera and the flash.

Preparations and Precautions

BEFORE YOU TRAVEL, especially if it's by air, try to anticipate and plan your movement through the airport and customs. Carry your cameras, film, and digital media as personal carry-on luggage when boarding a plane, boat, or similar transport. Theft, damage, breakage, and x-rays are the things to be most concerned about when in transit with photo gear. Before you travel, check to see if your insurance covers your cameras in the country of your travels. If your camera breaks or is stolen in a foreign country, you can often replace some of your gear, but this is a costly and time-consuming effort. The best insurance is to carry your camera everywhere you go. Consider carrying a backup camera, too, if you expect to travel on rough roads and plan to be traveling for more than a few weeks.

Adventure travel often means packing more gear than you normally would, especially if you are carrying a camera hard case for protecting cameras in desert sand, on water, in snow, etc. Before you fly, inquire about your carry-on allowances, as this varies from airline to airline, and for domestic and international flights. When traveling by air within a country, your carry-on and checked baggage is often more restricted than when flying in bigger planes on international flights. An

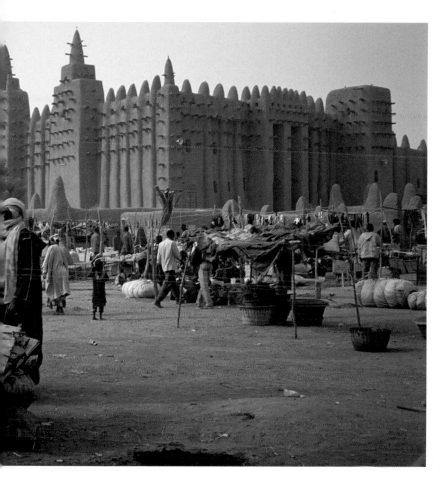

allowance of one checked bag and one small carry-on is typical. Airlines will charge you for each kilogram over the limit and for extra bags—this can get very expensive. If you plan to make multiple connecting flights and in-country flights, pack as wisely as possible for your trip.

When I travel to a foreign country, I compile a list of my cameras and lenses and their serial numbers. I sign, date, and notarize the list before I leave. This list is handy should your equipment be lost or stolen while

Scouting the location the previous day, I noticed that morning light provided the best light on the mosque of Djenne, Mali. To blend in, I didn't move from my location and took photos as shoppers and merchants moved in and out of my frame.

traveling. Also, the list will verify that you were in possession of the items when you left your home country. I am vigilant about the safety of my cameras when I am traveling. If possible, I carry them with me at all times when in transit, and I do not let them out of my sight. Although I have had various expedition gear stolen, I have not had any camera equipment stolen while on a shoot. I once had a close call when our group was disembarking from a flight in Thailand and another passenger grabbed our camera bag from the overhead compartment and raced for the exits. We gave a loud chase, and the thief dropped the bag. The best insurance for theft is keeping a sharp eye on your camera bag.

X-ray and Customs

With the mandate in the United States and other countries to x-ray all checked baggage with powerful new x-ray machines, you should never allow film to go in checked luggage. The x-ray used for checked luggage will fog and damage your film. The x-ray device that security passes your carry-on through before you board the plane will not harm your film unless it is high-speed 400 ASA film or higher. However, the effect of x-rays on film is cumulative, so if you anticipate that your film will pass through the carry-on x-rays more than 15 times in your travels, you can ask security to hand check; sometimes they will allow this procedure.

If allowed, a hand inspection of film will take time, so arrive early, especially because the security officer may decide to swab all of your film canisters to check for explosives. You can speed up this process by taking all

Tip

In foreign countries, often the simple act of pointing to your camera and pointing to the subject is enough to communicate the fact that you'd like to photograph them. Always read up about native customs before traveling to a foreign culture. Always smile.

of your film out of the boxes or canisters before you go through security. The good news for digital photographers is that x-rays will not harm your digital media, including compact flash, SD or micro-drive disc, or hard drives.

Immunization

You can check with the Centers for Disease Control (CDC) for requirements for travel overseas. The CDC has a Web site with extensive travel information. With certain diseases, such as cholera, an outbreak may be limited to a certain area within a country.

In the case of malaria, preventive drugs vary according to region, depending on the disease's resistance to certain drugs. Check with the embassy of the country in which you are traveling to learn more about immunization requirements.

The stack of dry goods in this Guatemalan store attracted my eye instantly because it was a slice of local life. To bring more light into the interior, I opened the doors to the sunlight outside.

FOLLOWING PAGES: Summer in the Alaskan bush means mosquitoes—many, many mosquitoes. On one summer trip to the Brooks Range the locals in Barrow claimed the "mossies" that year were the worst they ever saw.

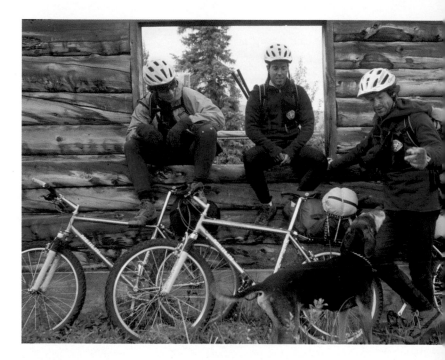

Adventure is not all action: Adventurers at an Alaskan fishing camp relax during an eight-week bike trek across the Alaskan Range.

Returning Home

When you are back home, it is time to unpack and unwind. Make a check of all of your camera equipment. Before storing it for the next trip, make sure that everything is operational and check for moisture or sand damage. Clean camera bodies by wiping the external body with a cloth or chamois. Use compressed air to clean out the camera's internal workings.

To check your digital camera sensor, begin by shooting a blank white sheet of paper. Download the white image and look at it on your computer monitor. If you notice dark specks on the viewed image it means there is dust on your digital CCD or CMOS sensor. Use a sensor cleaner to remove the dirt from the sensor. Sensor cleaners are widely available at camera stores. Follow the instructions care-

fully to avoid damage to your sensor. You can also have the digital camera sensor cleaned professionally at most camera-repair facilities.

Editing and Reviewing Images

Organizing your photos as soon as you return from a trip is important. As time passes and the excitement of the trip wears off, so will your enthusiasm to edit the hundreds of photos you shot. If you are shooting film, have it processed as soon as you return home. If you have digital files, transfer all of your photo files to a folder in the internal or external hard drive of your computer; then make a copy of the files on CD or DVD. This will ensure that you have two copies of your photo files, each in a different location.

Now it is time to edit your film or digital files. The important purpose of the first edit is to remove photos that are obviously bad. Toss photos that are out of focus or are poorly exposed into the trash.

An easy way to edit and group photos is to separate them into three categories: the super selects, which are the 10 to 20 best stand-alone images from the trip; the selects, which are the next-best photos, suitable for slide shows to illustrate your trip; and the remaining photos, which are those that do not have the best composition or lighting, but are still good enough to stay out of the trash.

If you are editing film transparencies or print negatives, you may want to scan your super-select photos into a digital format and burn them onto a CD or DVD so that you can easily print them, move them on the computer, send them via the Internet, or post them to your Web site. If you do not own a scanner,

Tip

When shooting adventure and action, know the abilities of the people you're photographing to avoid accidents. People will often exceed the limits of their ability for the camera.

This palm tree climber was trying to mimic the style that the locals used to retrieve coconuts. I knew her to be an experienced rock climber and athlete, so when I asked if I could photograph her I knew she was well within her limits and would not feel pushed to perform for the camera.

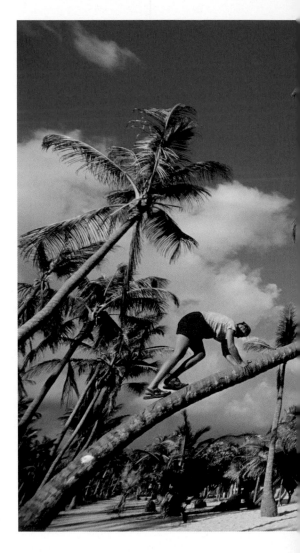

you can have the photos scanned at a photo lab. Shop around for the best lab, since quality and price vary considerably.

Before storing slides, prints, and CD/DVD files, be sure basic caption information is included with the photos to allow for easy retrieval in coming years. Store your photos and other media in a cool, dark place, such as

a file cabinet or closet. Computer photo files can be kept on an external hard drive.

Once you have completed your edit and stored your files, it's time to share your photos with your friends and family. Many manufacturers make presentation software that makes it possible to show photos on digital projectors or on your television.

AT FIRST GLANCE it would seem that unless you are a full-time adventure athlete, adventure photography is something that you will have little opportunity to apply yourself to; however, nothing could be further from the truth. When learning how to shoot action photos, there are many ways you can begin practicing and honing your skills when you are far from the mountains or wild rivers. In this chapter I'll talk about "crossover"; by that I mean how you can apply adventure shooting skills and techniques to your everyday photography.

There are many places just around your neighborhood, everyday outdoor activities, and amateur team sports where you can sharpen your eye for shooting adventure and action. These are not exercises that will train you to react faster, because the more you shoot, the more tuned in to the activity you will become, and speed will follow naturally. Instead, these crossover exercises will teach you to approach the game the same way a professional photographer prepares before shooting an event or an expedition. This exercise simply makes you see a game or sporting event as a photographer, not as a spectator. As a photographer, you approach the activity by looking for photos that tell the story of the game.

In the introduction I spoke about adventure photography being part anticipation and part reaction. The best way to sharpen your reac-

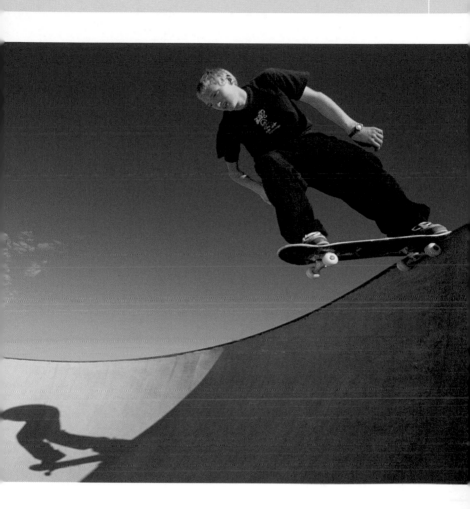

tion time is not when you are shooting your first raft crashing through a rapid, but at home shooting at the local sports field, the skateboard park, or on a bike ride around the block. The preparation for photographing a Little League baseball game or kids at the skateboard park is the same as for any adventure.

What separates a snapshot from a good photo is the planning that goes into making the shot. Before going out to shoot, pro photographers always have some kind of plan, which includes a mental image of the type of

Warm evening light and an extreme photo angle add drama to this shot of a skateboarder about to drop in at a skate park.

Charles Kogod

A 300mm telephoto lens and a shallow depth of field help to isolate the catcher in a portrait during a softball game.

photos they want to shoot. If you begin with a rough idea of the photos you want to shoot, you can then work backward and decide what camera, lens, and other equipment you might need to get those photos.

When you preconceive the photos, keep the ideas simple and flexible. Before shooting a Little League baseball game, for example, think of photos of the pitcher winding up for a throw, a kid sliding into home plate, etc. Having a general idea of what photos you want will give you a focus and help you make not only the right lens and camera choice, but also help you decide when and where you need to position yourself to shoot the photos.

In this exercise, let's photograph a Little League baseball game. We have already decided on some of the photos we would like to shoot. Now it's time to work backward and decide on the lens and gear you might need. To photo-

graph a kids' baseball game you will need a long lens; a 70-300 or 70-400mm lens would work best. Why? Just as in deciding the gear you chose on an adventure, you first determine what will be the average distance from your shooting position relative to the subject you are shooting. In a baseball game the rules of the game restrict you from getting very close to the players. For this reason you will require a telephoto lens.

If you are shooting at a skateboard park, however, you can stand very close to the edge of the skateboard ramps and therefore can use an extremely wide lens, such as a 16mm fisheye, which captures a 180-degree field of view. In baseball, if you are shooting the game with a big lens, you can figure that your typical shooting position will be 30 to 50 feet from the action. With this lens in mind and your knowledge of how the sport is played, you now can determine where to position yourself to take photos.

Remember as you plan this out that you are essentially making the same decisions you would make if you were deciding strategy for shooting a rafting trip or a climbing expedition: You are anticipating the best place to position yourself to capture action. In determining your position, you should consider the position of the sun in relation to your subject. Front- or side-lighted subjects will be better lighted than backlighted subjects. If you do find yourself shooting into the sun with a large telephoto, be sure the lens has a lens hood; this helps to reduce lens flare on your photos.

When I shoot a game like baseball, besides watching the action at home plate, the pitcher's mound, and first base, I will also keep an eye

Tip

Must-have gear for shooting in the sun on an open playing field are a hat, water, and an energy bar.

A portable flash freezes the action as a goalie blocks a ball from the net. The background sunset adds additional drama to this local game.

on outfielders catching pop fly balls. I may move my position so I can shoot team players in the dugout watching the game, then move my position at a pitched ball. What determines what I shoot is the story I want to tell. Do I want to focus on just one player, or do I want to shoot a bigger story, such as a winning team with a star pitcher? If the playing field is

Michael Nichols

immaculate, I might want to use a wider lens and capture the players on the playing field. If the game is tied in late innings, I might focus my lens on the stands to see if I can capture any tension in the crowd, or focus on the coaches or players in the dugout.

Let's try another activity. Bike riding with friends or children is a good choice because it

Careful framing with the fence post creates a window to isolate the spectators and ball players at a local game.

combines different shooting angles with movement and action on a predetermined route, either a road or bike trail.

The photos we want to shoot will be an action shot and a photo that says something about what the trail is like. For the action shot, let's use the panning technique that was discussed earlier to shoot a photo of the bikes as they ride past your position on the side of the trail. The second photo will be a wider scenic shot of the cyclist riding down the trail. Let's work backward from these preconceived ideas we have for the two photos we want to shoot on this bike ride. First we have to decide what camera and lens we will need. For the first photo we will need a camera that allows us to change the shutter to a slow shutter speed so we can blur the background as we pan the cyclists as they ride past. The lens for this shot can be a wide-to-normal zoom, such as a 28-105 zoom. The other shot, a scenic photo of the riders on the trail, can be made with the same lens and camera combination.

Many point-and-shoot cameras will enable you to adjust the shutter speed to shoot a panning shot. An SLR camera will also work, since you will have a faster reaction time and a faster motor drive to shoot a sequence burst of several photos as the riders go past. For the panning shot, the sunlight will determine the best place to shoot. Because you will be shooting at such a slow shutter speed, you may want to try shooting this panning photo on an overcast day when the sun's light is not so bright. To ensure you have the best photo possible, you can have the riders ride past for photos a couple of times.

For the second biking photo in this exercise, the scenic photo of the riders should say

something about the trail. For this photo, you will have to choose your position carefully. The best perspective to show something like riders on a bike trail is from above. This photo is probably best shot from a small hill or rise along your bike route, or from a bridge that the bike route passes under. You can scout the

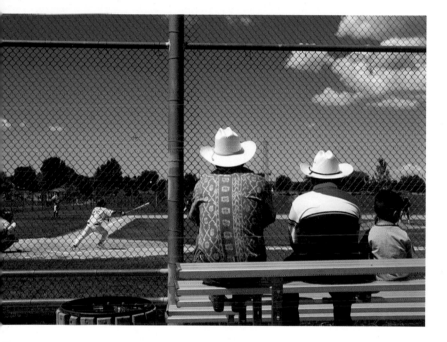

route in advance or keep a sharp eye out for potential shooting positions as you ride. Before the ride, communicate to the others that you intend to stop to shoot some photos along the way. This will help you organize the riders when you want to stop for a photo.

These and other exercises teach you to determine in advance the cameras you might need as well as the strategy you will employ to shoot the photo. With a little practice before your trip, you will mentally prepare yourself to think like a sports and adventure photographer.

FOLLOWING PAGES:
The last rays of sun are captured between the feet of these runners. A ground-level angle gives a unique view of the runners' feet as they move past the camera.

EQUIPMENT CHECKLIST

Minimum gear
- padded camera bag
- camera body
- one or two favorite lenses with caps and hoods
- film or memory cards
- lens brush
- flash
- spare batteries
- Sharpie and notepad in Ziploc

Options
- extra camera body
- specialized lenses: 16 mm fish eye, macro, big telephoto
- filters: polarizer, warming filters 81a, 81b, split neutral density
- handheld exposure and flash meter
- flash cord for off-camera flash operation
- tripod, mono pod, or mini pod
- compressed air for cleaning cameras/lenses
- mini softbox or reflector
- wireless transmitter to trigger camera remotely
- waterproof hard case
- silica gel to dry cameras in the tropics
- cooler and ice pack to keep film cool in desert heat
- LED button light or penlight
- extra Ziplocs to organize and protect film, lenses and miscellaneous stuff
- Chamois to clean water off camera and lenses

Repair kit
- Swiss army knife with tweezers
- jeweler's screwdriver set
- small pliers
- gaffer's tape

Other stuff to consider on a photo outing
- water
- couple of energy bars
- rain jacket or windbreaker
- headlamp
- sun cap or wool cap (season dependent)
- small first-aid kit
- compass

WEB SITES

Adventure Activities
http://www.adventuresportsholidays.com
Adventure Sports Journal Online
http://www.adventuresportsjournal.co
The Alpine Club of Canada
www.alpineclubofcanada.ca
American Alpine Club
www.americanalpineclub.org
American Society of Media Photographers
www.asmp.org
Bill Hatcher Photography
www.billhatcher.com
Centers for Disease Control and Prevention: Department of Health and Human Services: www.cdc.gov/travel
Climbing Magazine
www.climbing.com
Consular Affairs: Information and Assistance for Canadians Abroad
http://www.voyage.gc.ca/consular_home-en.asp
Dawn Kish Photography
www.dawnkishphotography.com
Digital Photography Review
www.dpreview.com
Embassy Information
http://embassyinformation.com/
Gordon Wiltsie-AlpenImage, Ltd.
www.alpenimage.com
GORP
http://gorp.away.com
Jimmy Chin Photography
www.jimmychinphotography.com
Mountain Bike Magazine
http://www.mountainbike.com
nationalatlas.gov
http://nationalatlas.gov/natlas/Natlasstart.asp
National Geographic Adventure Photography Tips: http://www.nationalgeographic.com/pathtoadventure/phototips
National Park Service
www.nps.gov
National Weather Service Internet Weather Source: http://weather.noaa.gov
Outdoor Photographer
www.outdoorphotographer.com
Outside Magazine

http://outside.away.com
pdnonline (photo district news)
 www.pdnonline.com
Popular Photography and Imaging
 www.popphoto.com
Project Visa
 http://www.projectvisa.com/
Rock & Ice The Climbers Magazine
 http://www.rockandice.com
SportsShooter.com
 www.sportsshooter.com
U.S. Department of State: International
 Travel: http://travel.state.gov/travel
USGS Geography: The National Map
 http://nationalmap.gov
USGS river flow data for the nation
 http://waterdata.usgs.gov/nwis
Weather Underground
 www.wunderground.com

MAGAZINES

American Photo (bimonthly)—Interviews and features about professional photographers, equipment reviews, industry news.

Outdoor Photography (10 times a year)—Covers wildlife, scenic, adventure, sports, underwater, etc.; reviews cameras and lenses; how-to and field-tip columns by regular contributing professional photographers.

Photo District News (monthly)—Professional magazine. Industry news, interviews, equipment reviews; monthly theme, such as photojournalism, fashion, weddings, etc.

Petersens PHOTOgraphic (monthly)—Consumer magazine with equipment reviews, how-tos, classified ads

Popular Photography (monthly)—Focus on photography reviews and camera and lens tests. Also how-tos and tips, classified ads.

Shutterbug (monthly)—General photography with how-to tips, industry updates, and equipment reviews and test reports on camera equipment.

Digital Photographer (monthly)—Guide to digital cameras and products, with how-to articles and equipment reviews.

PC Photo magazine—All aspects of digital photography and computer photo software. Interviews with professionals, how-tos, equipment reviews, and camera tests.

Outdoor and Nature photography (quarterly)—Articles on all facets of outdoor subjects, travel, nature, action, and adventure photography.

National Geographic Adventure (monthly)—Features on outdoor adventure and exploration; photos by some of the best outdoor photographers.

Outside (monthly)—Consumer magazine that runs one or two features on outdoor athletes and expeditions. Keeps up with trends in outdoor sports and recreation.

BOOKS

Mountain Light by Galen Rowell, Sierra Club Books
Adventure America, National Geographic Books
Galen Rowell: The Art of Adventure, Sierra Club Books
Chased by Light, by Jim Brandenberg, Northward Press
Workbook of Photo Technique, by John Hedgecoe, Michael Beazly Publishers
Rick Sammon's Complete Guide to Digital Photography, W.W. Norton & Co.
National Geographic Expeditions Atlas
Hot Shots: 21st Century Sports Photography, Sports Illustrated Press

Bill Hatcher is a regular contributor to National Geographic magazine and many other publications including *American Photo, Newsweek, Life, Outside, Adventure,* and *Outdoor Photographer.* In the course of a 20-year career, his assignments have taken him all over the world to document adventure, science, and expedition stories of all kinds. He lives in Colorado.

National Geographic Photography Field Guide Action & Adventure

Text and photographs by Bill Hatcher

Published by the National Geographic Society

John M. Fahey, Jr., *President and Chief Executive Officer*

Gilbert M. Grosvenor, *Chairman of the Board*

Nina D. Hoffman, *Executive Vice President; President, Books and Education Publishing*

Prepared by the Book Division

Kevin Mulroy, *Senior Vice President and Publisher*

Kristin Hanneman, *Illustrations Director*

Marianne R. Koszorus, *Design Director*

Leah Bendavid-Val, *Director, Photography Books*

Staff for this Book

Rebecca Lescaze, *Editor*

John C. Anderson, *Illustrations Editor*

Cinda Rose, *Art Director*

Kay Hankins, *Designer*

R. Gary Colbert, *Production Director*

Mike Horenstein, *Production Project Manager*

Rachel Sweeney, Teresa Neva Tate, *Illustrations Specialists*

Dana Chivvis, *Illustrations Assistant*

Connie D. Binder, *Indexer*

Manufacturing and Quality Control

Christopher A. Liedel, *Chief Financial Officer*

Phillip L. Schlosser, *Financial Analyst*

John T. Dunn, *Technical Director*

Chris Brown, *Manager*

Founded in 1888, the National Geographic Society is one of the largest nonprofit scientific and educational organizations in the world. It reaches more than 285 million people worldwide each month through its official journal, NATIONAL GEOGRAPHIC, and its four other magazines; the National Geographic Channel; television documentaries; radio programs; films; books; videos and DVDs; maps; and interactive media. National lGeographic has funded more than 8,000 scientific research projects and supports an education program combating geographic illiteracy.

For more information, please call 1-800-NGS LINE (647-5463) or write to the following address:

National Geographic Society
1145 17th Street N.W.
Washington, D.C. 20036-4688 U.S.A.

Log on to nationalgeographic.com;
AOL Keyword: NatGeo.

Library of Congress Cataloging-in-Publication Data
Hatcher, Bill, 1959-

National Geographic photography field guide : action and adventure / text and photographs by Bill Hatcher.

p. cm.

Includes index.

ISBN 0-7922-5315-9

1. Photography, Instantaneous I. National Geographic Society (U.S.) II. Title.

TR592.H38 2006

778.9'9796—dc22

2005054369

FRONT COVER: Harsh afternoon light was the key to creating the dynamic shadows in this photo of a mountain biker riding at Grand Falls, Arizona.